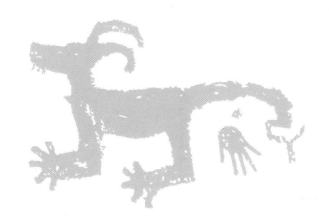

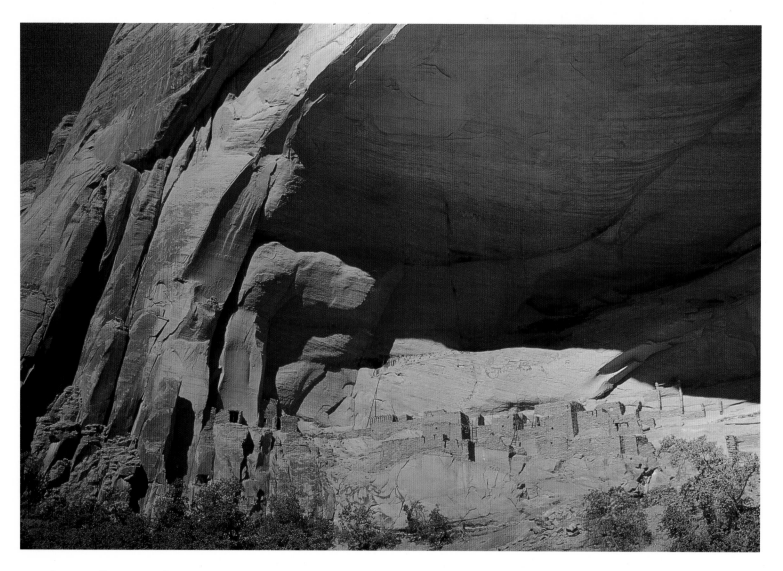

BETATAKIN ("LEDGE HOUSE" IN NAVAJO)
Anasazi, c. 1250-1300
NAVAJO NATIONAL MONUMENT, NAVAJO NATION, ARIZONA

(OPPOSITE) RIO GRANDE STYLE PETROGLYPHS
Pueblo, c. 1300-1500
PETROGLYPH NATIONAL MONUMENT, NEW MEXICO

ANCIENT WALLS

Indian Ruins of the Southwest

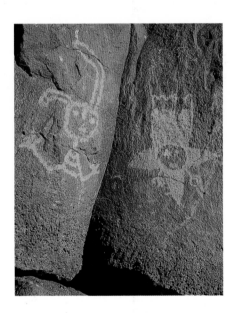

Chuck Place

with interpretive text
by Susan Lamb

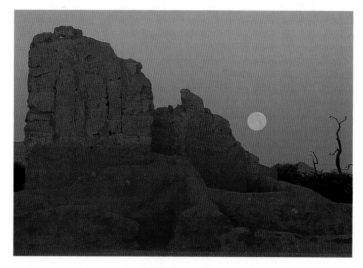

Produced for Fulcrum Publishing by
Companion Press
Santa Barbara, California
Jane Freeburg, Publisher/Editor

Essay text and captions by Susan Lamb
Designed by Linda Trujillo

Anasazi artifacts photographed for this book are from the
collection of the Museum of Northern Arizona, Flagstaff.
With special thanks to Linda Eaton for her assistance.

Library of Congress Cataloging-in-Publication Data
Place, Chuck.
 Ancient walls : Indians of the Southwest / Chuck Place.
 p. cm.
 ISBN 1-55591-125-0 — ISBN 1-55591-126-9 (pbk.)
 1. Indians of North America—Southwest, New—Dwellings.
2. Indians of North America—Southwest, New—Antiquities.
3. Petroglyphs—Southwest, New. 4. Southwest, New—Antiquities.
I. Title
E78.S7P52 1992
979'.01—dc20 91-58636
 CIP

Printed and bound in Hong Kong by DNP America, Inc.

ISBN 1-55591-126-9

9 8 7 6 5 4 3 2 1

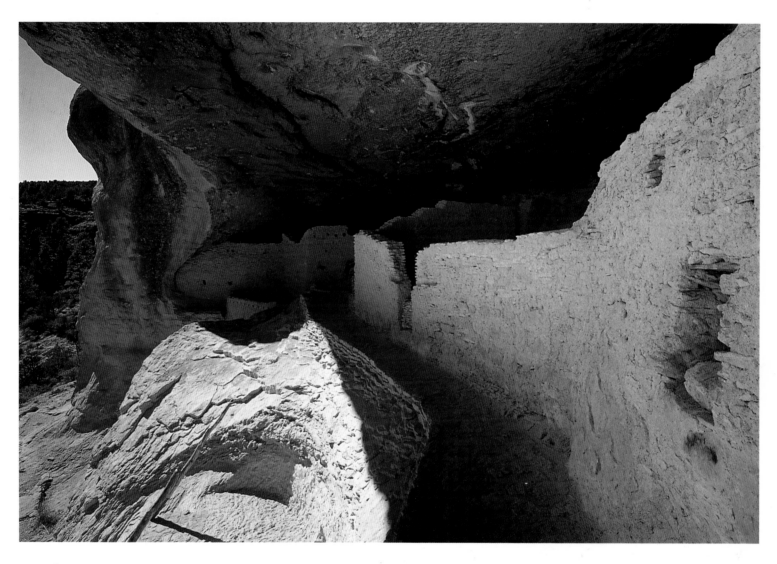

GILA
Mogollon, c. 1280
GILA CLIFF DWELLINGS NATIONAL MONUMENT, NEW MEXICO

Black-haired people wearing serapes and aprons of white cotton lived here; perhaps a dozen families in the forty rooms of the caves at Gila. They cultivated the land along the river and atop the mesas, probably growing amaranth and tobacco as well as the classic southwest triad of corn, beans, and squash.

Many Native American people of the Southwest are linked to these ancient builders. Some of them remember very old stories and still live close to the land. When these people speak, we can hear the past in what they say.

And, we can quietly observe the natural world. Finding our way in it, sometimes we also find ourselves face to face with the people who lived so close to it a thousand years ago.

This land sustained great civilizations. Yet it is a land where little except rocks and rabbits occurs in abundance. Peach-colored sandstone, smooth as a body languid in the sun, layers of buff and chocolate shales draped discreetly over faults—here, rocks are the flesh as well as the bones of the earth.

Massive cliffs retreat from the weather, exposing layers of other colors, different textures. Caves form where water seeping through bedrock emerges from canyon walls, dissolving the lime that cements their minerals together. Mudstones split along planes of deposition. If you look closely at the golden bluffs, you see the sweeping lines of sand dunes fossilized aeons ago.

The people who lived here a thousand years ago did look closely, at everything. Like the ancient Greeks, they wondered at what they saw, and peopled the earth with spirits to personify cause and effect, cloud and cornplant, sun and butterfly. They spoke to these spirits every day.

Left: Fine yucca sandal
Basketmaker III, Tsegi
Right: Braided yucca sandal
Pueblo III
Museum of Northern Arizona collection

It is all there in the rock art—the strange and the ordinary,
the mysterious and the commonplace. For centuries, images
have been dabbed onto stone with mineral paints or tapped into
its dark varnish of manganese and iron oxides.

Many designs are virtually identical from one end of the South-
west to the other. Some of the symbols are abstract—zigzags, boxes,
patterns of dots like the dazzle from looking straight at the sun, and
intricate geometric patterns suggesting weaving or choreography.

Some are representational. The Fremont, neighbors of the
Anasazi, portrayed kilted people with fantastic headdresses. The Navajo
painted pictures of the Spanish military, riding horses and wearing huge
hats.

Most often, they reflected a peaceful world. Pictures of shields or
warriors are the exception, only occasionally found among the turtles and
handprints. Everywhere, there are snakes, birds, bighorn sheep, and
coyotes. Mythical creatures, too.

Rock art could have been part of ceremonies or conjuring, for
good hunting or for rain. It was the work of people who did not distin-
guish between religion and survival. Petroglyph–covered rocks are often
found near sources of water, like Irish shrines.

We can sense what the sky has always meant to cultures such
as these. We find many Anasazi petroglyphs of the moon and Venus,
or perhaps of the Crab Nebula supernova, which occurred in A.D. 1054.
Daggers of sunlight still pierce spirals the ancient people chipped into rock

crevices. The Navajo painted constellations on cave ceilings in Canyon de Chelly. And among the bearpaws and cornstocks on the Hopi clan rocks is neatly chiseled:

1969 JULY—MAN LAND ON MOON

We see other connections between the rock art of the past and the indigenous religions of today. Respect for the everyday—and close observation of the landforms and lifeforms of the natural world— these are still deemed vital to one's existence. There are songs to greet the dawn, songs for grinding corn, and prayers to thank the land. A Hopi told folklorist Harold Courlander: "Almost everything we do is a religious act, from the time we get up to the time we go to sleep."

This is a splendid world of ochre and vermillion, fragrant with the dusty scent of sagebrush. Red-tailed hawks spiral toward heaven with piercing, prideful screams, their rusty feathers backlit by the sun. Pronghorns graze on the grasslands, and every big rock has its defiant lizard king. At nightfall, coyotes let loose garbled yowls that could raise the hair on a dead man.

But the climate here is harsh. The ancient people did not try to accomplish the same things in winter that they did in summer. They lived according to the seasons.

Twice a year, fierce gales blow for weeks as westerlies shift to easterlies in spring, and back again in autumn. A baking calm roasts the

first half of summer. Then breathtaking storms burst on the land, and the footfalls of powerful spirits can be heard in the thunder. Enormous, billowy clouds like silver jellyfish trail purple streamers of rain across the sky. Afterwards, the ground is covered with yellow flowers and the melons ripen quickly.

Soon the crystalline air grows cold and sharp. Iridescent sundogs hover high at noon, presaging snow. Winter blizzards follow, and the world fragments into small black bits in the overwhelming whiteness. When the sky finally clears, plumes of fine snow fly like flags from buried walls and boulders.

Yet this tempestuous weather brings little moisture, whether to Mogollon mountain or Hohokam desert, Anasazi plateau or Sinagua valley. The Southwest people husbanded the water with great care. To grow beans and cotton, Hohokam farmers dug an elaborate system of canals from the meager desert rivers to their fields. The Mogollon built checkdams to catch storm runoff in the upland washes. And all of them patiently tended the springs: clearing away debris, shading the source, honoring the spirits.

They lived with memory of famine. Crouching near an anthill, a young Anasazi farmer would watch the tiny creatures, busy as always, collecting food. He would tell his wide-eyed son the old story, that ants once had bodies more like those of people. But one year, long ago, there was a drought, and the lazy humans ran out of food. The little ants kindly invited all the hungry people to stay with them. But these people ate and ate, almost

BASKET,
DEVIL'S CLAW & BEARGRASS
BOYNTON CANYON, ARIZONA
MUSEUM OF NORTHERN ARIZONA
COLLECTION

11

everything in sight. The poor ants were too polite to say anything; they just tightened their belts until their bodies took the form we see today. That was *very* selfish and irresponsible of us, the farmer would tell his son. We musn't ever run out of corn again.

They knew the history of every mouthful of food they ate and of everything they wore and used, whether hunted, gathered, or grown.

They knew when and where to look for grapes, and how to stalk bighorns. They knew how powerful and intelligent bears are.

Young boys crowed about their skill and good fortune in clobbering rabbits for the winter stewpot with their curved throwing sticks. In the summer, men came back with tales of their adventures while hunting deer in the mountains. Everyone knew the animals well—innards, bones, and hide—and thanked them for their sacrifice.

What a treat when the currant bushes grew heavy with sweet, sun-warmed berries! A treat, but not a surprise, because people knew the frost had been gentle and the rain had come at the right time. In a good year like that, the yuccas would bloom and bear fruit. The agaves swelled thick hearts for roasting. The earth could be bountiful with plenty of piñon nuts, especially in Anasazi country, and stalks of sandfood for the Hohokam.

Every year, the farmers talked about when the squash blossoms would be ready to pollinate. They were anxious all during the early, hot part of summer. But when the fierce black clouds finally boiled up from the south, hammering down great big raindrops like pebbles, everybody was relieved. The children rolled and splashed in the mudpuddles.

Tusayan Red-on-Buff Ladle,
Found near Betatakin Ruins
Navajo National Monument
Museum of Northern Arizona
collection

When I lived at the Grand Canyon, I mentioned to a Hopi man that I found it hard to see how the Anasazi could have grown corn on the canyon rim, where it was so dry and cold. The next spring, he brought me blue corn from his home on the mesas. During the second week of June, he said, I was to plant handfuls of kernels a foot deep, where the soil was cooler and maybe a little damp. Then the rains of July would come and the corn would grow fast, ripening before the frost.

I said sure, but when should I thin the plants? He looked puzzled. I blundered on: "You know, so they won't steal water from each other." There was a shocked silence.

"Oh, they like to live together," he said finally. "They give each other shade, and help each other stand up in the wind. When it rains, they all hold their leaves out so the water runs down to the middle where everybody can get some." He was quiet for a moment, then smiled: "That's the way *we* like to live, too."

Some scholars believe that human beings were better off before they began to farm. Their diet was more varied, and they actually spent less time in pursuit of a mouthful than when they began to tend their food. If plants didn't bear or game animals stayed away, a family could just wander south or up a watercourse until they found better forage. Why spend a lifetime in the same place, grinding corn and picking grasshoppers off bean plants?

Because a good life means more than just food—it means community. These were village people. No matter how large some of their

13

settlements grew, they were still villages in which everyone knew everyone else. Everybody mattered.

Even the dogs were important: they barked alarm at intruders and excitement when the hunters came home. Grandparents told bedtime stories to their families, lying nestled together on the rooftops watching the stars and sometimes the mouse in the moon. Women painted intricate designs—among the Mimbres even quail and caterpillars—on pottery. They packed mud around the openings of granaries to keep out mice and beetles. Men wove cotton into sashes and skirts. Children shooed birds away from the drying corn and made a cheerful racket with their shouts and games.

Village criers called out to the sun and the people. Kinsmen honored the ceremonies of their clans, stomping plank footdrums in the kivas or playing turkey-bone flutes by the springs. Good cooks, funny clowns, thoughtful priests—this was their community.

Architecture mirrors society. Within the pueblos of the Southwest people shared everything: walls, water, and protection from the elements. Many of the pueblos are massively constructed of stone and a prodigious amount of mud mortar, possible only with an exceptional level of cooperation among the builders. Kivas, the religious rooms, are incorporated into the pueblos, to be a part of every day life.

The pueblos were profoundly practical, built where no land suitable for farming would be wasted. Thick roofs held the meager heat inside in winter and insulated against the merciless sun in summer. The stone walls absorbed the low rays of late afternoon and the winter sun, to

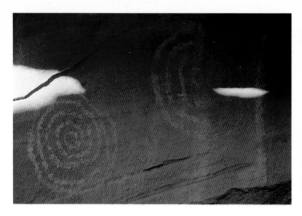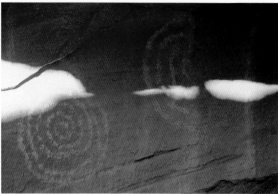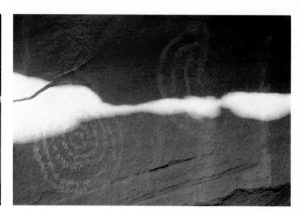

Solar Spirals
Holly Group
Hovenweep National
Monument, Utah

warm the rooms within. Some of the pueblos built in canyon alcoves had running water of a sort: a trickle of water percolating down through the bedrock.

At the same time, the pueblos are lovely, as natural as lichen on junipers. In proportion and grace, they seem almost like stone creatures grown from the land, in harmony with canyon and forest, desert and sky.

The people of prehistory made middens—rubbish piles— quite near their villages. Here they tossed broken pottery, animal entrails, and other castoffs. They often buried their dead here. They did not regard things which were no longer useful as loathsome—they set them aside with respect.

Although theirs was a world of villages, it was a wide world. In the mesa-top pueblos in Colorado, splendid red-and-blue macaws from Mexico screeched and flapped their wings. Young women living on the rim of the Grand Canyon wore bracelets made of seashells from the Gulf of California several hundred miles away. Copper bells from Chihuahua tinkled amid the honeycomb walls of Chaco, while the Sinagua and Hohokam played an exhausting ball game that originated in the highlands of Mesoamerica.

Ideas were traded, too. Sometimes trade was from neighbor to neighbor, but probably strangers also traveled great distances. Some believe that "Kokopelli," the humpbacked flute player seen so often in rock art, represents an itinerant peddler approaching a village, playing his flute, pack on back.

These great Southwestern cultures were more alike than different. They knew each other, shared, and traded. Their combined influence extended from Nevada to Texas and from Mexico to Colorado. Their most dynamic period stretched from about A.D. 900 to 1100—a time when these creative people became aware of their civilizations' great possibilities. The following two centuries were prosperous eras of massive building projects and extensive trade networks.

Eventually, these civilizations declined. Their communities dissolved; the people abandoned their homes. Why? Despite a century of archaeological research, a satisfying answer eludes us. Scholars have sought to blame a climate change, exhaustion of resources, plague, invasion, or warfare. No one of these could entirely account for the end, but perhaps together they do.

The people of prehistory moved and mixed, forming new communities. Some of these communities survive today. Their people still tell stories about the ancient times and can trace their ancestry back to places that are now national monuments.

When the Spanish came to the Southwest in the sixteenth century and the Anglos came in the nineteenth, they were fascinated by the antiquities they found everywhere. Many early military and missionary expeditions included journal keepers, who sketched and described these sites in detail.

Settlers followed the conquerors. They scratched their names onto walls and rock art, cannibalized the masonry to build their homes, and dug up

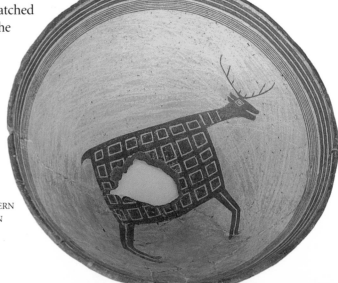

MIMBRES BOWL
Pueblo III
GRANT COUNTY,
ARIZONA
MUSEUM OF NORTHERN
ARIZONA COLLECTION

ancient pottery to decorate them. When collectors in the East and Europe became aware of the beauty of the Southwest's prehistoric artifacts, the devastation began in earnest. Pothunters shipped crates of pottery and grave goods to private collectors and museums all over the world.

Serious archaeologists agitated for protection of the sites. In 1906, the government took action. Congress passed the Federal Antiquities Act, and in 1907, Theodore Roosevelt placed eighteen areas under federal protection.

Southwestern archaeology began in the 1880s. There have been many heroic figures—and breakthroughs in techniques and understanding—over the past century. Sometimes, researchers put their heads together to reach a consensus. During a 1927 meeting in Pecos, for example, archaeologists agreed upon a chronology of Anasazi development—which has since been modified—that established a common vocabulary with which to compare notes. Scientists from other disciplines contribute important clues. For example, astronomer A. E. Douglass pointed out in the 1930s that tree-rings could be used for dating buildings. Anthropologists who collect stories from the descendants of prehistoric cultures offer leads that can be verified by excavations.

And so we continue to learn about past civilizations whose ancient walls are in our midst. Can we learn *from* them? Their descendants tell stories about the virtues of life in a difficult land. These photographs also tell the stories. They illustrate the elements of a timeless way of life: landscape, community, reverence. Those elements surround us yet today. We may live with them, too, in our own way.

—SUSAN LAMB
Flagstaff, Arizona

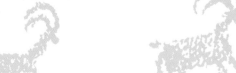

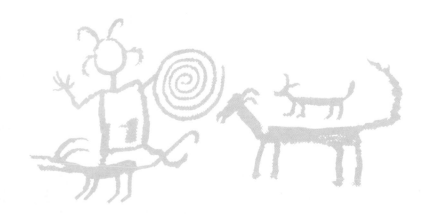

A Landscape of Rock & Time

It defies the imagination to think of human beings flourishing in this challenging landscape for centuries. But time is the ally of understanding. Watching clouds move and lizards wait, pollen glitter in sunbeams and snow drift against ancient walls, we find that this rocky land no longer intimidates us. Such moments glow in these photographs that were obtained with due respect for time.

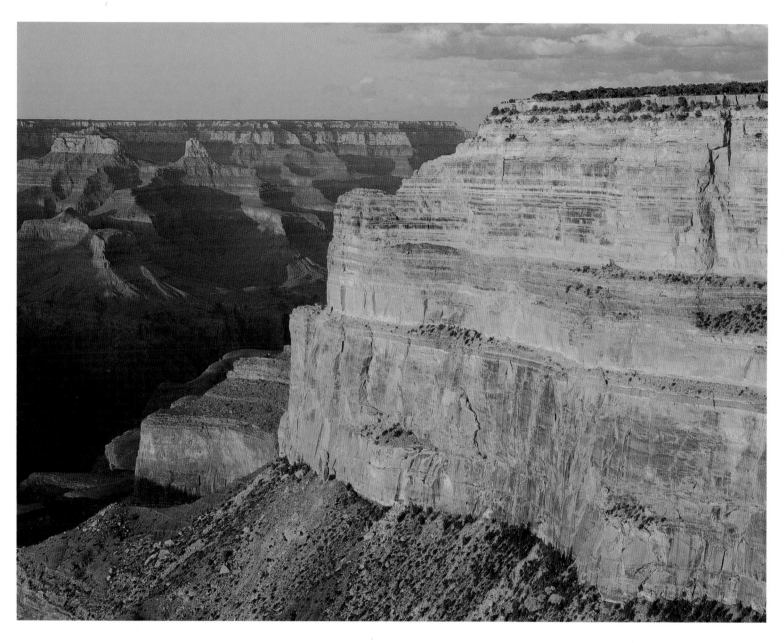

HOPI POINT AT SUNSET
GRAND CANYON NATIONAL PARK, ARIZONA

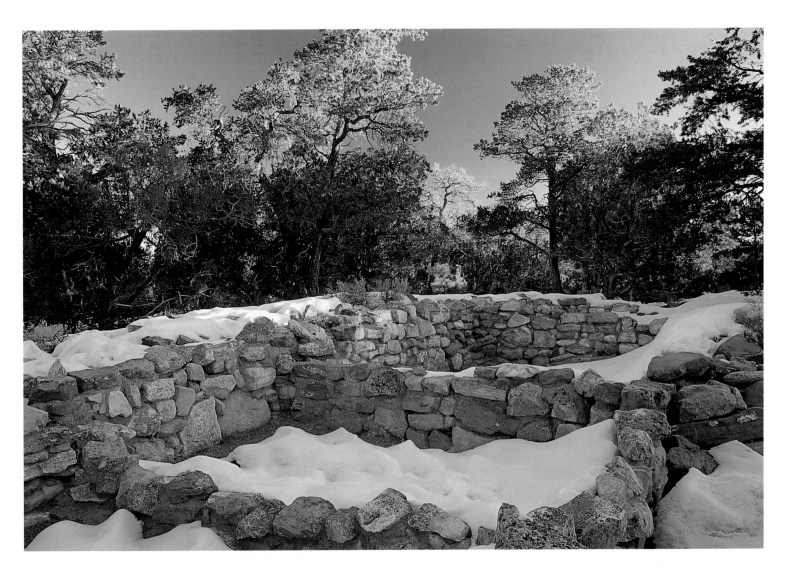

TUSAYAN RUIN
Anasazi, c. 1185
GRAND CANYON NATIONAL PARK, ARIZONA

*Although it is only one of hundreds of small sites now known at Grand Canyon, Tusayan's excavation in
1930 taught early archaeologists a great deal. Anasazi culture varied through the Southwest. Anasazi means
"ancient strangers" in the Navajo language. The Hopi call them* Hisatsinom, *"those of long ago."*

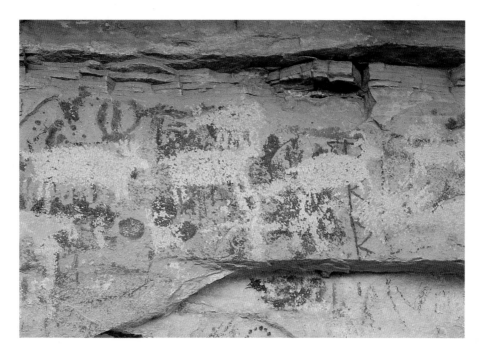

PETROGLYPHS AND PICTOGRAPHS, BELOW THE RIM
Within Anasazi and Cohonina
cultural ranges, pre-1150
GRAND CANYON NATIONAL PARK, ARIZONA

". . . the long-dead artists and hunters
confront us across the centuries . . .
I was here, says the artist. We were
here, say the hunters."
 Edward Abbey, Desert Solitaire

Rock art is almost impossible to date with certainty.
The petroglyphs here were chiselled into the painted
pictographs, indicating that they are of different
times as well as of different styles. We cannot be sure
who put these here, but many do resemble those of
the Kayenta Anasazi heartland.

SHORT-HORNED LIZARD
WUPATKI NATIONAL
MONUMENT, ARIZONA

*"Horned toads" are most active
during the noonday heat. With
majestic slowness, they incline
their crowned heads to catch ants
on their sticky, roll-up tongues.
Should their coloring fail as
camouflage, they may spurt
blood from their eyes to startle
predators. Late in the afternoon,
they burrow into the sand and
in winter, lie dormant there.*

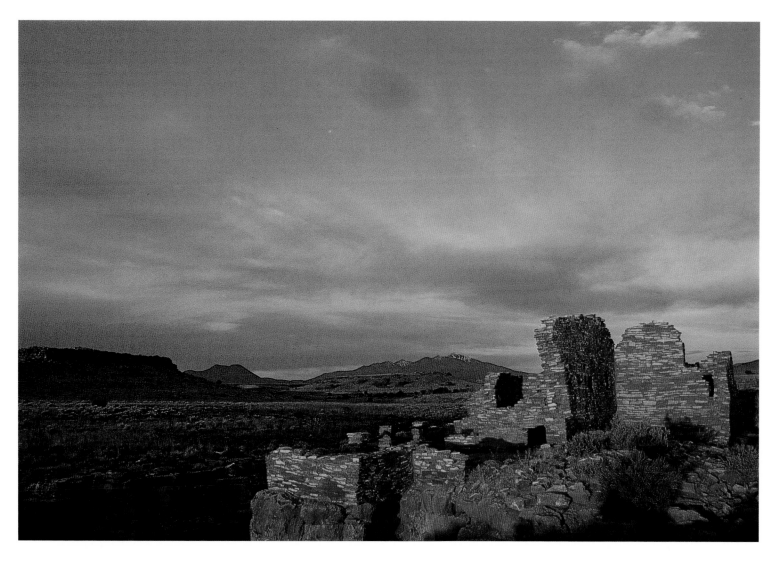

Lomaki (Hopi for "Beautiful House")
Attributed to Anasazi, c. 1192
Wupatki National Monument, Arizona

Lomaki was named for its fine stonework, although its walls were most likely covered with plaster both inside and out. It seems that for these people, every stage of a task held the potential for beauty. The nine rooms in two stories were built by the Anasazi, although Cohonina may have lived here, too.

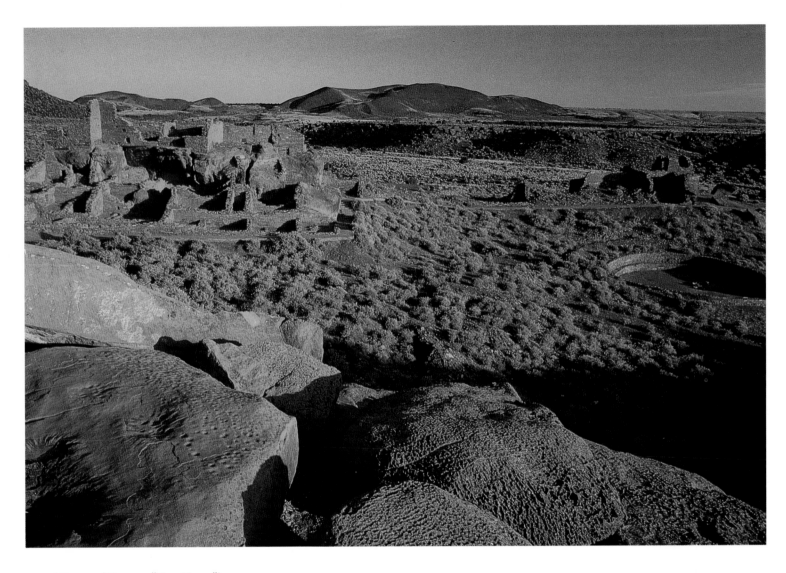

WUPATKI (HOPI FOR "TALL HOUSE")
Sinagua, c. 1120-1215
WUPATKI NATIONAL MONUMENT, ARIZONA

*Rainfall in this region increased just as fine ash and cinders from Sunset Crater had accumulated to
mulch the earth. Local Sinagua who had fled the eruption moved back and thrived with the good farming
conditions. Next to a spring, they built Wupatki—about a hundred rooms in four stories—to house around
125 people.*

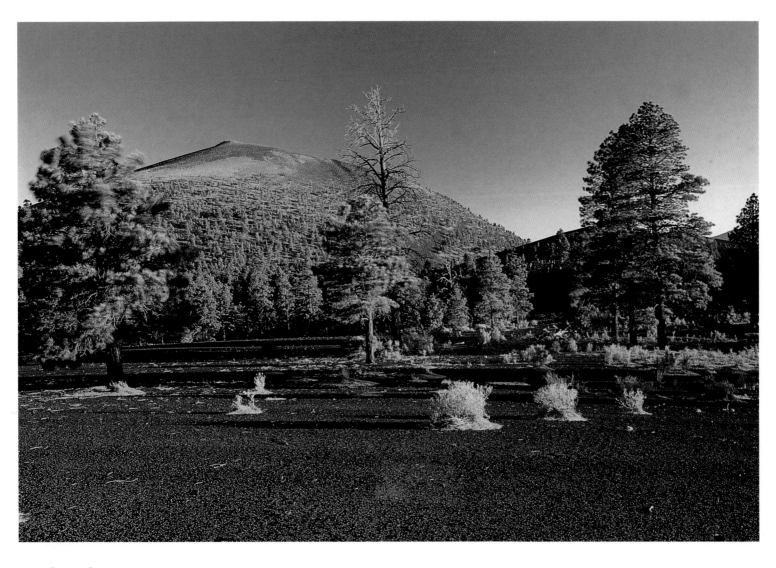

SUNSET CRATER
Erupted 1064 until c. 1220
SUNSET CRATER NATIONAL MONUMENT, ARIZONA

The Hopi tell what happened at Sunset Crater this way: "The people of that village were getting out of hand. They gambled in the kivas, even gambling away their wives! Then there was a strange light on the mountain. Most people kept fooling around, but a few good people left in time. Soon a cloud of fire came down and destroyed all who remained. You see, when times are hard, people behave themselves. Disasters come with the easy life, when people get lazy and forget to honor the spirits."

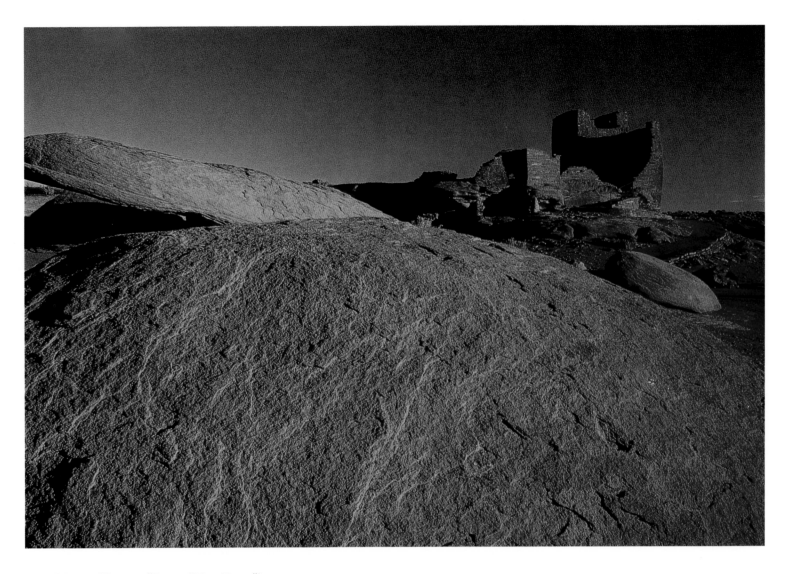

WUKOKI (HOPI FOR "BIG AND WIDE HOUSE")
Twelfth century
WUPATKI NATIONAL MONUMENT, ARIZONA

Set on a boundless plain under the vast sky, Wukoki is visible from far away—though it almost looks like a natural part of its red sandstone island. Once the improvement in farming due to Sunset Crater's eruption was recognized, people came from everywhere to live in this area. A number of large pueblos were built, often near massive earth cracks and blowholes which may have had some special meaning.

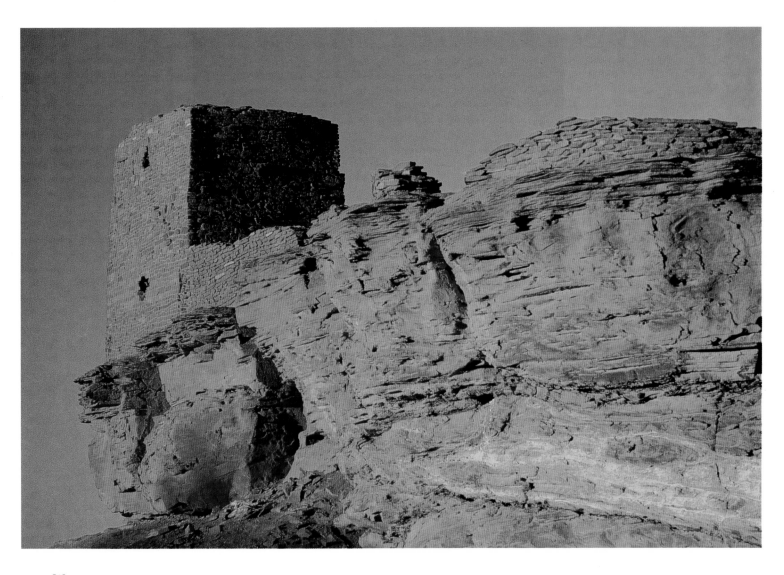

WUKOKI
Twelfth century
WUPATKI NATIONAL MONUMENT, ARIZONA

Populations in the prehistoric Southwest were mobile, often shifting this way or that, sharing and changing their ways of life. At Wupatki, Hohokam traits such as the stone-lined ballcourt and Anasazi styles of masonry architecture and decorated pottery blend.

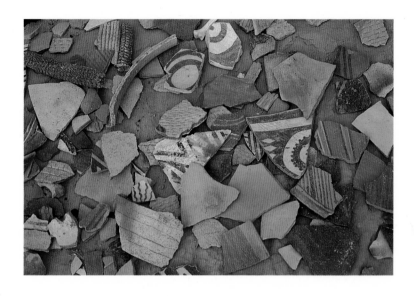

Pottery sherds & Corncobs at Keet Seel
Origins and dates of manufacture vary
Navajo National Monument, Navajo
Nation, Arizona

The potsherds that give Keet Seel its name are of varied origins and purposes. Often the utilitarian ware was left unsmoothed on the outside; coils of clay and the fingerprints of the maker are still clear. Fine bowls were often painted on the inside, mugs and jars on the outside, with paint made of boiled plant juice that turned black upon firing.

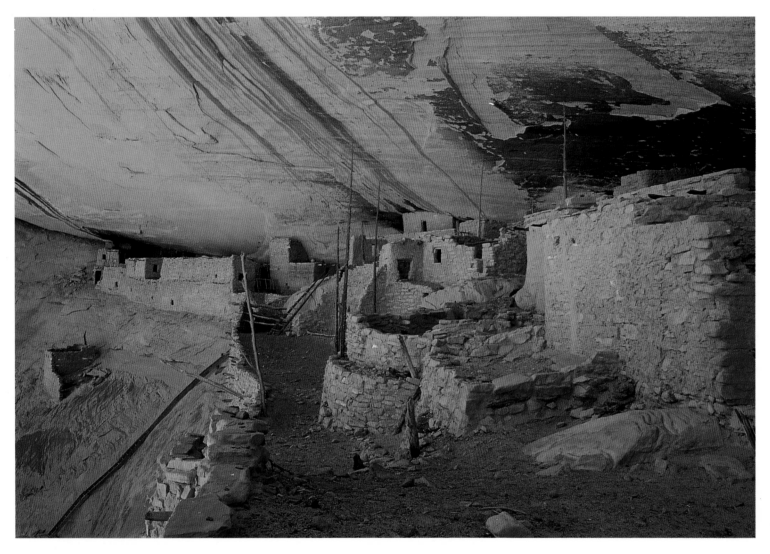

KEET SEEL ("BROKEN POTTERY" IN NAVAJO)
Anasazi, c. 1250-1300
NAVAJO NATIONAL MONUMENT, NAVAJO NATION, ARIZONA

Anasazi farms and masonry villages once dotted the open country below the canyons. In the mid-thirteenth century, drought and perhaps overuse destroyed the soil cover. Then the people built cliffhouses like this one and farmed up in the canyons. But after only fifty years, even the land there became gullied and unusable, and Keet Seel was abandoned.

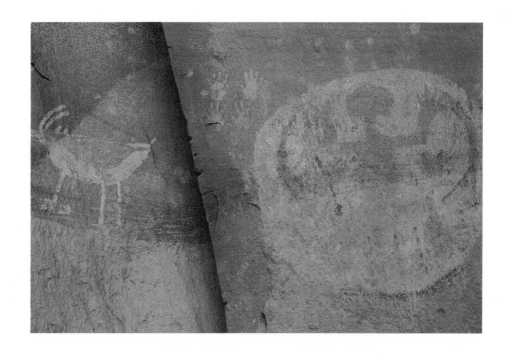

Pictographs at Betatakin
Attributed to Kayenta Anasazi
Navajo National Monument, Navajo
Nation, Arizona

Handprints, a bighorn, and a possible clan symbol were painted on this rock. Some scholars believe that shield images, often placed prominently on cliffs close to dwellings, may be heraldic emblems much like European coats of arms of the same period. They may symbolize clans or societies similar to those of Hopi and Zuni villages today. The long-limbed figure within the circle is of a type commonly referred to as a "lizard man."

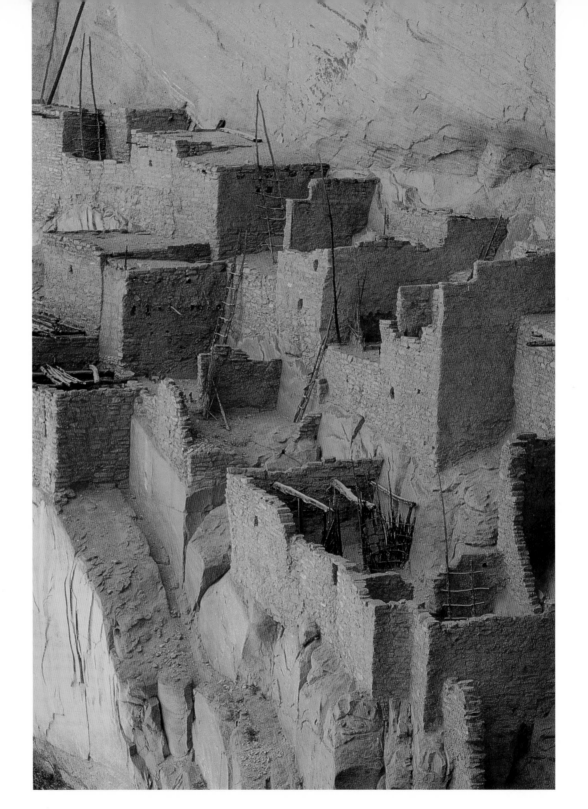

BETATAKIN ("LEDGE HOUSE"
IN NAVAJO)
Anasazi, c. 1250-1300
NAVAJO NATIONAL MONUMENT,
NAVAJO NATION, ARIZONA

*To look down from Betatakin is to
invite vertigo. Why build in such a
place? The south-facing alcove is
deep, cool in summer and heated
by the low rays of the sun in winter.
The overhanging rock protects the
dwelling well, even after six
centuries of abandonment.*

31

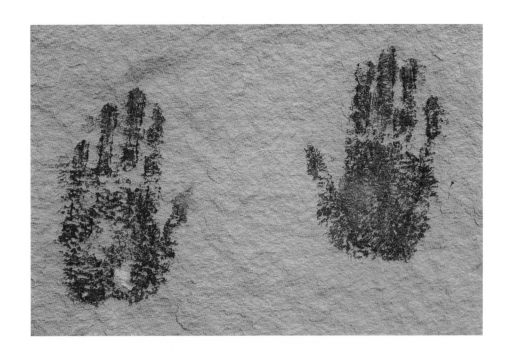

PICTOGRAPHS
Within Mesa Verde Anasazi range;
possible Fremont influence
NATURAL BRIDGES NATIONAL MONUMENT, UTAH

Although they developed paintbrushes of plant fibers
and hair, the people of prehistory never gave up the
practice of slapping their painted hands on rock walls.
They made red or brown paint of hematite; white
came from gypsum, lime or chalk; black often from
charcoal. Blues and greens were mixed from
cuprous minerals. Other colors came from plant-
derived pigments, but did not survive as well,
hence the "headless" pictographs sometimes seen.
Paint palettes, paint pots, and grinders with smears
of colorful minerals on them have been found in
some Southwestern ruins.

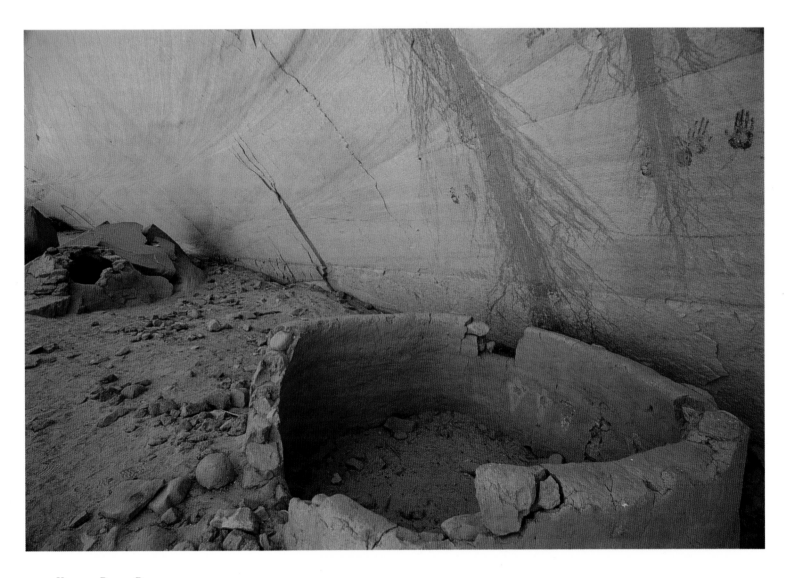

KACHINA BRIDGE RUINS
San Juan Anasazi
NATURAL BRIDGES NATIONAL MONUMENT, UTAH

In Natural Bridges, almost three hundred ruins have been found—all small in scale, reflecting the scant land available for farming in this area. Important archaeological advances were made in this and other dry tributaries of the San Juan River in the late nineteenth century, including the recognition of an early stage of Anasazi culture known as the Basketmaker.

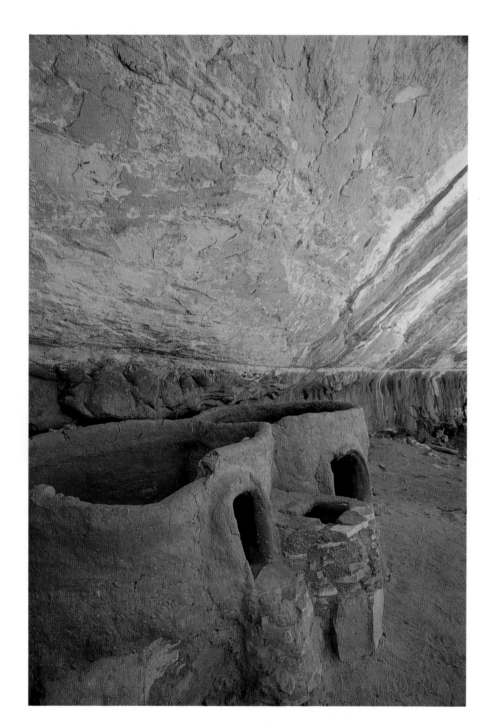

HORSE COLLAR RUIN
San Juan Anasazi
NATURAL BRIDGES NATIONAL
MONUMENT, UTAH

*These early granaries are made of mud
plastered over a framework of twigs, a
technique known as jacal. They could be
sealed with mud around a stone hatch
to keep out rats and mice. Storage
chambers, probably the most common
prehistoric structures found in the
Southwest, remind us that these
farmers husbanded their hard-won
harvest carefully.*

OWACHOMO (HOPI FOR
"ROCK MOUNDS") BRIDGE
NATURAL BRIDGES NATIONAL
MONUMENT, UTAH

*Streaks of color in this stone reveal
the layers of sand blown one way and
then the other before they were cemented
together as rock. Then a lazy river
meandered here, entrenching itself deep
into the sandstone. In flood stage, the
sandy water of the river churned against
the wall of a loop's inner curve, eventually
scouring through it. Geologically,
Owachomo is an old bridge, ready
to fall to the forces of erosion.*

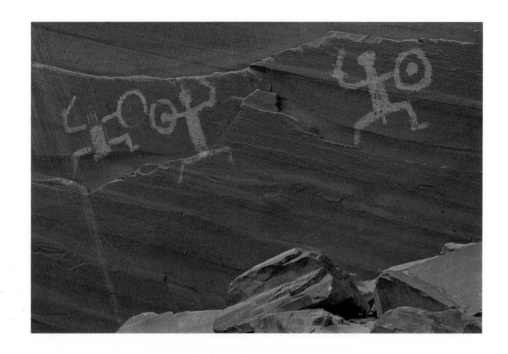

PICTOGRAPHS AT DEFIANCE HOUSE
Attributed to Anasazi, thirteenth century
GLEN CANYON NATIONAL RECREATION
AREA, UTAH

Possible emblems of a clan or an ancient society,
men waving shields and clubs defy all comers from
the cliff above a small pueblo two hundred feet up
the side of Forgotten Canyon. Once accessible only
via a dangerous toe-and-fingerhold trail across the
cliff, these pictographs escaped the ravages of vandals.

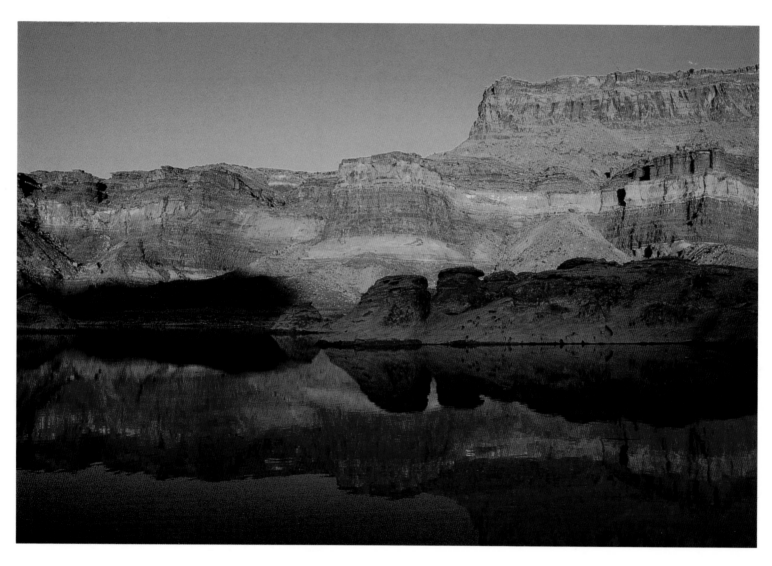

LAKE POWELL AND CLIFFS
GLEN CANYON NATIONAL RECREATION AREA, UTAH

Today, Lake Powell's waters reflect the cliffs of Glen Canyon, a vista very different from when the Anasazi lived here, centuries before the damming of the Colorado River. More than two thousand archaeological sites—the majority now flooded—were investigated in a massive rescue archaeology project undertaken before the dam gates were closed in 1963.

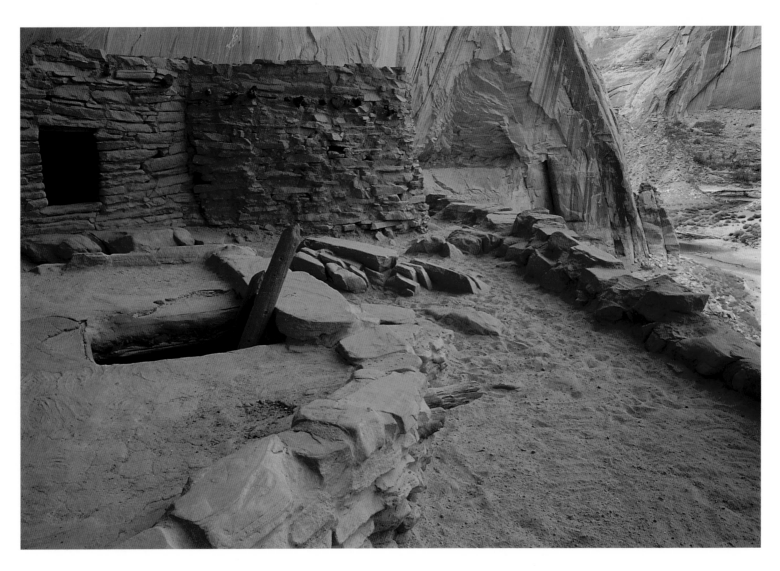

DEFIANCE HOUSE
Anasazi, c. 1250-1285
GLEN CANYON NATIONAL RECREATION AREA, UTAH

Defiance House, found undisturbed in 1959, conjures for us a vivid picture of vibrant Anasazi culture. They left arrowshafts and corncobs here, as well as flutes, weaving tools, and jewelry. Gaming pieces found here suggest the Anasazi had the leisure time for games.

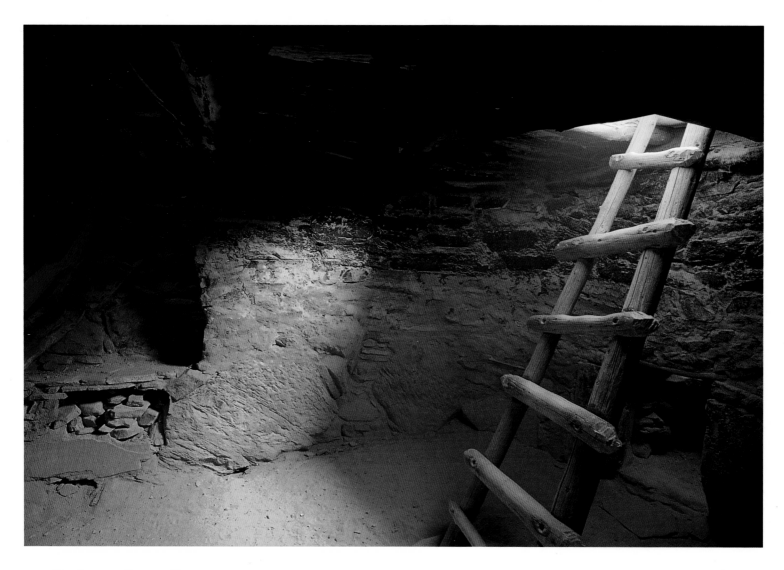

KIVA INTERIOR, DEFIANCE HOUSE
Anasazi, c. 1250-1285
GLEN CANYON NATIONAL RECREATION AREA, UTAH

Kivas, ceremonial rooms of the Anasazi, were vital to the community for ritual and fellowship. Kivas were usually entered through the roof by means of a ladder and featured niches for sacred objects. Air shafts helped keep a central fire burning. The Hopi and other Pueblo people still use kivas today.

ROCK ART RITUAL

Pockmarks around the heads and hearts of the horned petroglyph figures opposite are believed to have been made in prehistory—by projectiles hurled at the rock with considerable force and accuracy. Why? Perhaps the old standby explanation "for ritual purposes" will serve here. Modern graffiti mar the panel also.

Fremont culture developed independently of the Anasazi, but the two interacted and their regions overlapped. Fremont rock art often portrays broad-shouldered figures with elaborate headdresses, jewelry, and clothing.

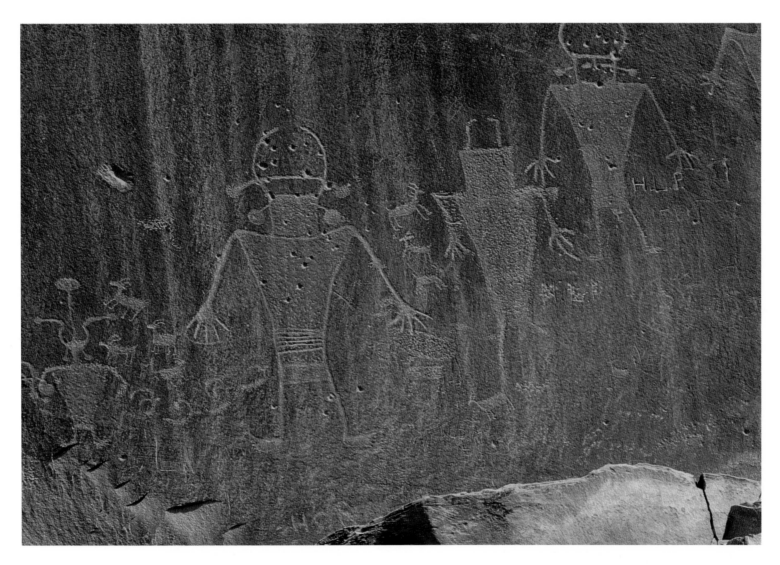

PETROGLYPHS
Attributed to Fremont culture
CAPITOL REEF NATIONAL PARK, UTAH

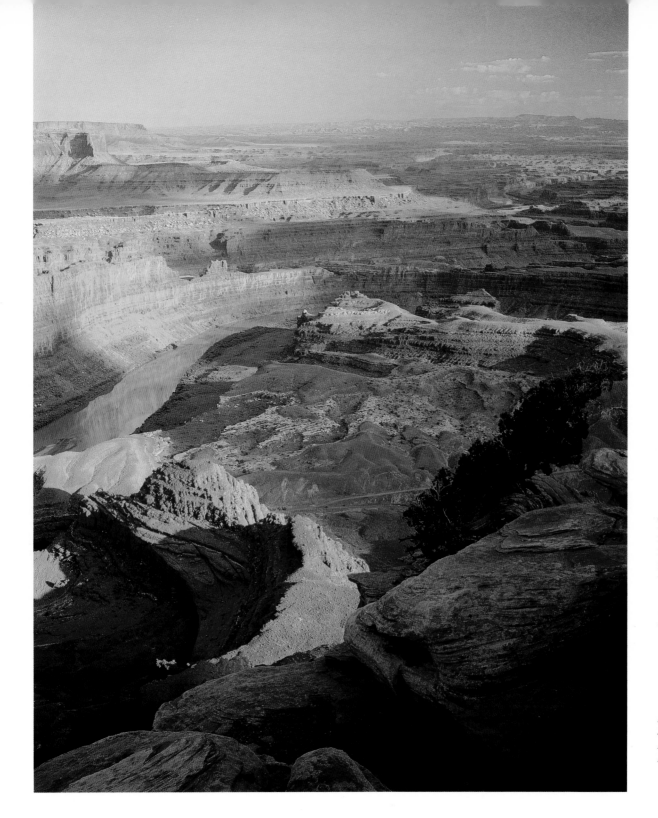

CANYONLANDS NATIONAL PARK & THE COLORADO RIVER, SEEN FROM DEAD HORSE POINT STATE PARK, UTAH

We tend to see such rugged land as problematical, the canyons as barriers, the mountains uncultivable. Yet to people of an earlier time this sort of topography proved far richer than a level meadow. Different food plants and wild game occur in each biome, providing infinite possibilities for subsistence.

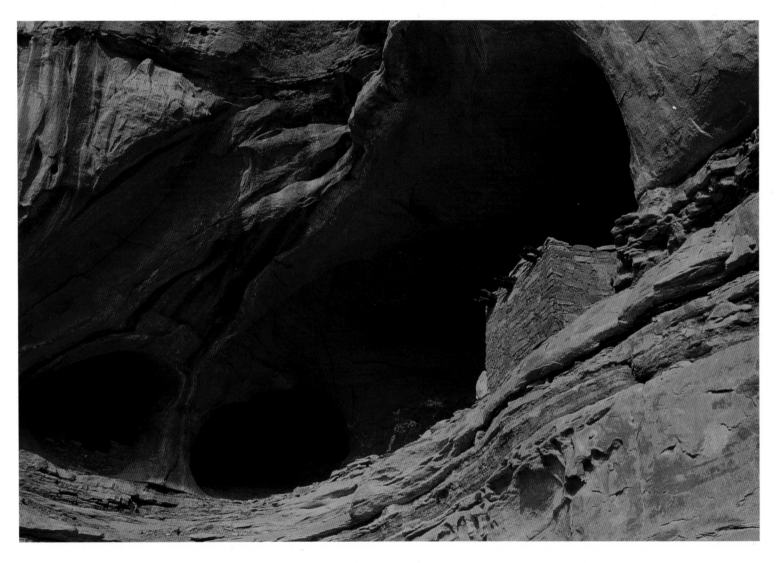

HORSE CANYON
Northeast periphery of Anasazi; southeast periphery of Fremont
CANYONLANDS NATIONAL PARK, UTAH

Tucked into this alcove are simple dwellings and granaries that evoke a sense of daily life in prehistory. Should he or she survive infancy and early childhood, an average person lived about forty years, although women of childbearing age suffered a higher mortality in those days. People in their sixties were venerable and looked to for wisdom.

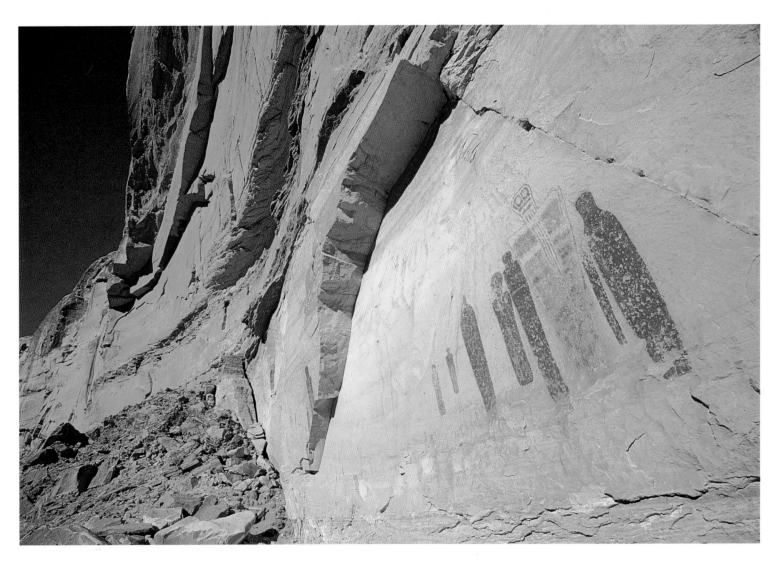

PICTOGRAPHS IN THE GREAT GALLERY
Barrier Canyon Style
CANYONLANDS NATIONAL PARK, UTAH

These ghostly beings are thought to be older—perhaps thousands of years older—than either Fremont or Anasazi rock art. They are huge, hunched, larger than life-size figures with masklike faces; missing their necks, their bodies elaborately decorated. Barrier Canyon style pictographs arouse our imaginations perhaps more than any others.

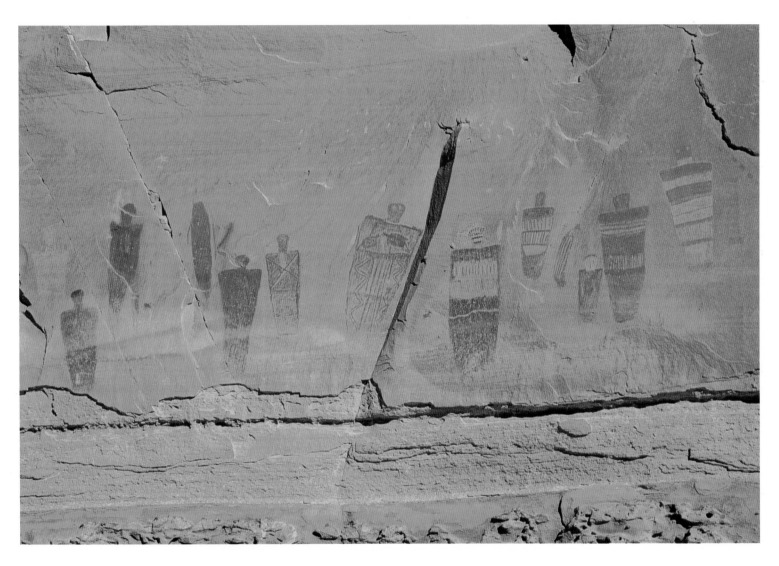

WALL OF PICTOGRAPHS, THE GREAT GALLERY
Barrier Canyon Style
CANYONLANDS NATIONAL PARK, UTAH

*Studies suggest these figures may represent "supernatural transformations of shamans," or they may
be shrines, perhaps for the dead. Evidence of their ritual importance includes signs of alteration—many
Barrier Canyon pictographs have been scratched, abraded, and repainted, shot with projectiles, or covered
with mud. Did they strike awe, fear, or respect into the hearts of prehistoric people?*

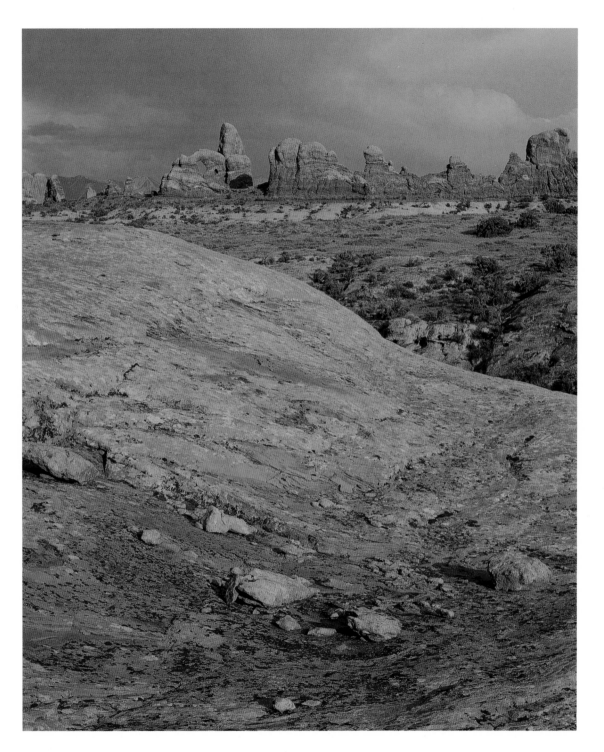

TURRET ARCH
ARCHES NATIONAL PARK, UTAH

Another mile of rock once protected this Entrada Sandstone, over 140 million years old. Now narrow stone fins, isolated by the weathering of parallel fractures, stand vulnerable. Water seeps into the sandstone, dissolving the cement that holds it together and prying off flakes of rock when it freezes. Released from the pressure under which it formed, the stone also simply sheds itself. Whimsical shapes, doomed to disintegrate, frolic briefly in geologic time.

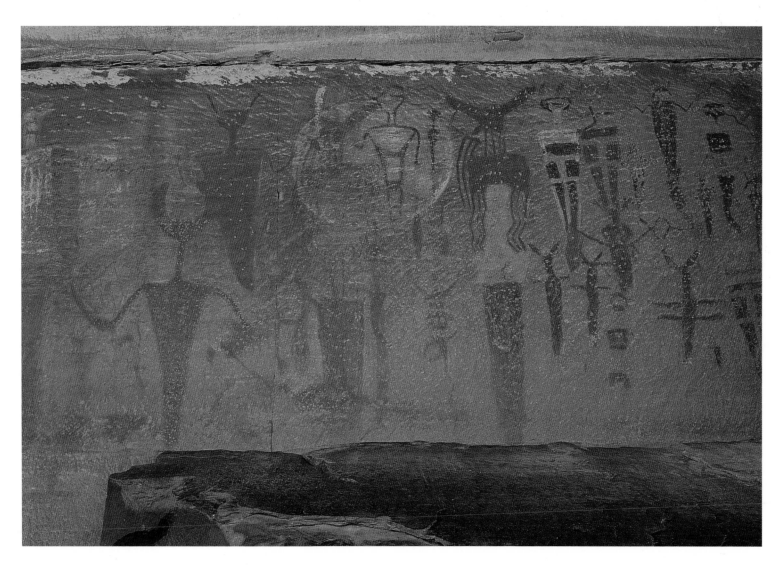

PICTOGRAPHS, COURTHOUSE WASH
Barrier Canyon Style
ARCHES NATIONAL PARK, UTAH

This remarkable panel of figures was placed on the National Register of Historic Places, but did not escape near-obliteration by vandals. The panel has been restored at considerable expense, but some clues to the past have been lost forever. Circular shield designs were superimposed on the Barrier Canyon figures, perhaps by the Fremont.

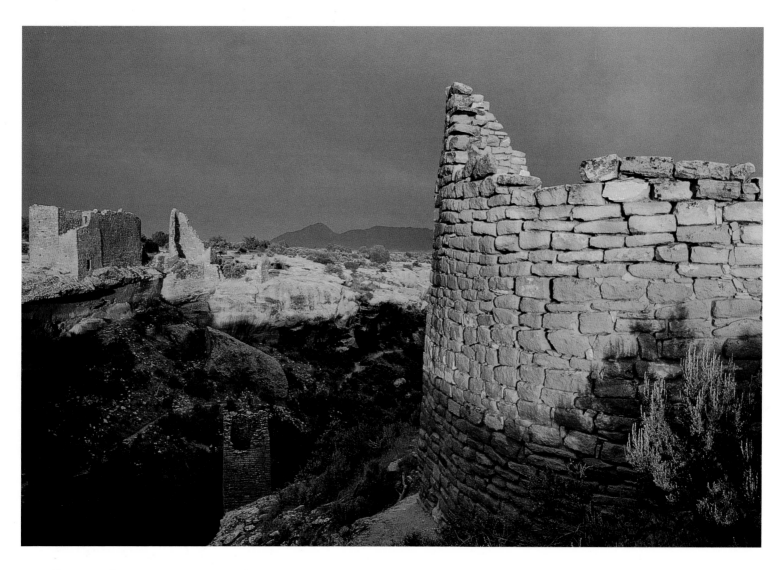

HOVENWEEP HOUSE
Anasazi, c. 1200
HOVENWEEP NATIONAL MONUMENT, UTAH

Hovenweep *means "deserted valley" in the Ute language. About eight hundred years ago, Anasazi built several large tower-pueblos at the heads of Hovenweep's canyons—they resemble the contemporary castles of Europe with their masonry towers commanding every approach.*

T-Doorway, Stronghold House
Anasazi, c. 1200
Hovenweep National Monument,
Utah

*It is thought the Anasazi built doorways
in a "T" shape to reduce drafts. Small
apertures higher up in the thick walls
of these buildings could have been for
ventilation. Some make good peepholes
for watching the trails to the springs,
but archaeologists have also observed
some openings aligned with the sun
on summer and winter solstices.*

COLLARED LIZARD
HOVENWEEP NATIONAL
MONUMENT, UTAH

*Collared lizards are fierce. They will bite
large creatures hard when molested,
although they usually prey on insects and
smaller lizards. They can run very fast on
their long back legs with their tails held out
for balance. Beautifully colored green with
white spots, they are named for their collar
of two black bands enclosing one of white.*

ERODED BOULDER HOUSE
Anasazi, c. 1200
HOVENWEEP NATIONAL MONUMENT,
UTAH

*Ever practical, the Anasazi used an
existing boulder as part wall, part roof
of this house. Their tower complexes were
constructed at the heads of canyons near
permanent springs. Checkdams built in
the draws leading to the canyons held back
the soil and trapped irrigation water. The
people of Hovenweep moved away in the
late thirteenth century, when a prolonged
drought hit the area. Even their carefully
designed dam techniques could not save
their farms.*

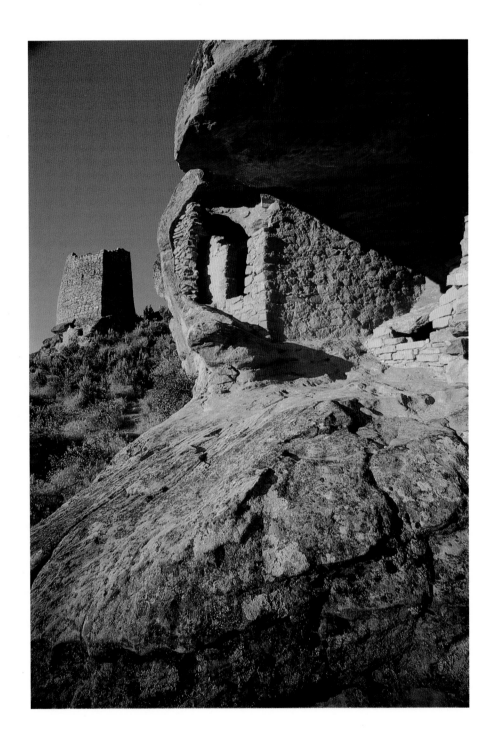

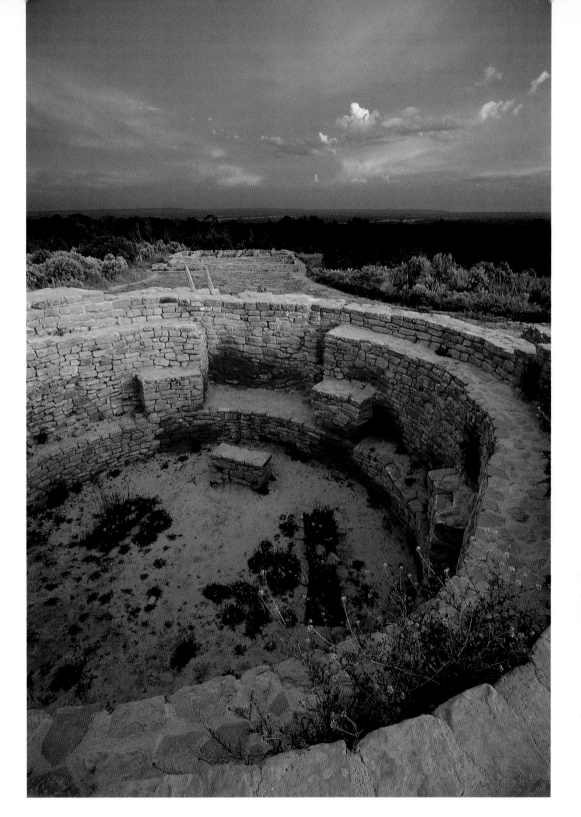

KIVA, FAR VIEW
Anasazi, c. 1100-1300
MESA VERDE NATIONAL PARK,
COLORADO

*Now open to the sky, this
magnificent kiva at Far View
resembles those of a more elaborate
Anasazi culture to the south—that
of Chaco Canyon. Openings in the
floor, called "vaults," were once
covered with plank foot-drums.
Imagine the pounding of these
drums during a ceremony meant
to coax rain from distant
thunderheads.*

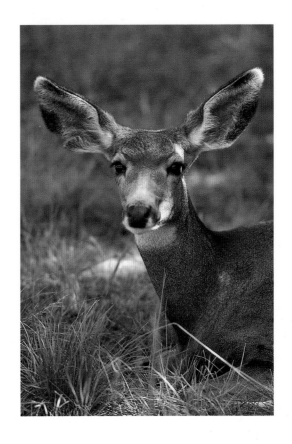

MULE DEER
MESA VERDE NATIONAL PARK, COLORADO

Mule deer adapt to the seasons. They will browse on anything from pine needles and mushrooms to flowers and acorns in summer, and on the cliffrose, sagebrush, and Mormon tea they find at lower elevations in winter—as long as water can be found within a couple of miles. Bucks are seldom seen during the summer, but once their antlers are shed of velvet they seem to materialize everywhere at once, preening and hopeful.

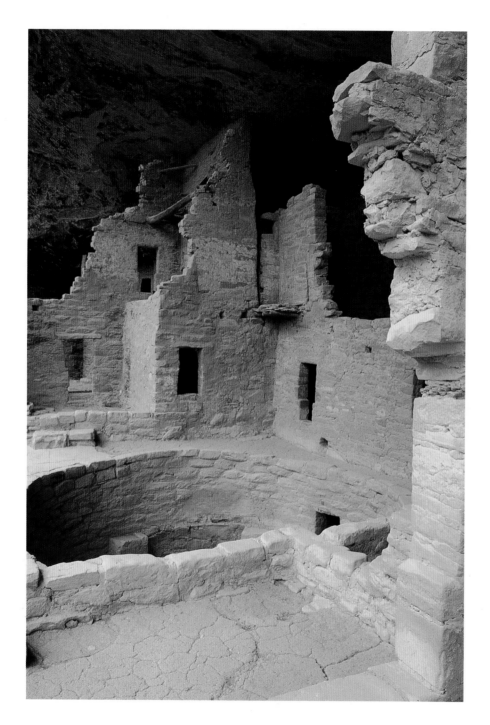

SPRUCE TREE HOUSE
Anasazi, c. 1200-1276
MESA VERDE NATIONAL PARK,
COLORADO

As many as one hundred people may have lived in this cliff dwelling of 114 rooms and eight kivas built into a natural alcove. The alcove formed as groundwater, percolating through the sandstone, encountered impermeable shale and seeped horizontally, dissolving the sandstone and cracking it away with freezing temperatures. This modest water source was a great boon to the Anasazi of Spruce Tree House.

KIVA D, SPRUCE TREE HOUSE
Anasazi, c. 1200-1276
MESA VERDE NATIONAL PARK,
COLORADO

*Cribbed beams resting on pilasters
supported the roof of this kiva, partially
reconstructed by the National Park Service
to illustrate Anasazi building techniques.
We describe kivas as ceremonial rooms.
The wider definition of "ceremony" among
people who use them today includes very
old rituals and meetings of traditional
societies—but men also weave the bridal
clothing for their nephews' wives in kivas,
and villagers gather to talk over the affairs
of their community.*

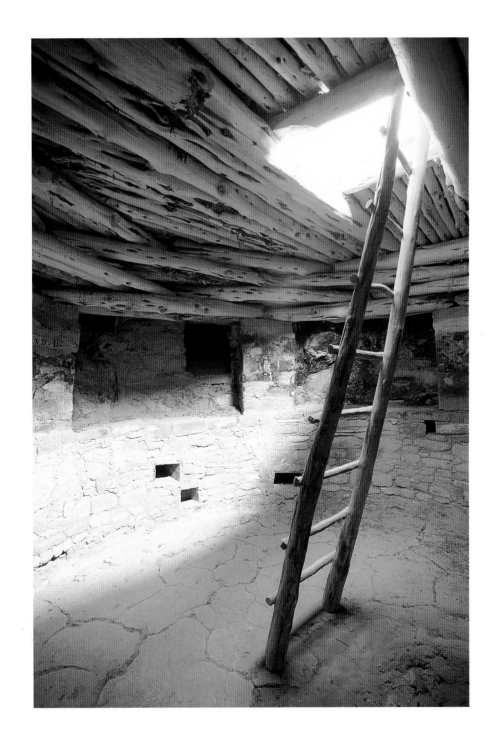

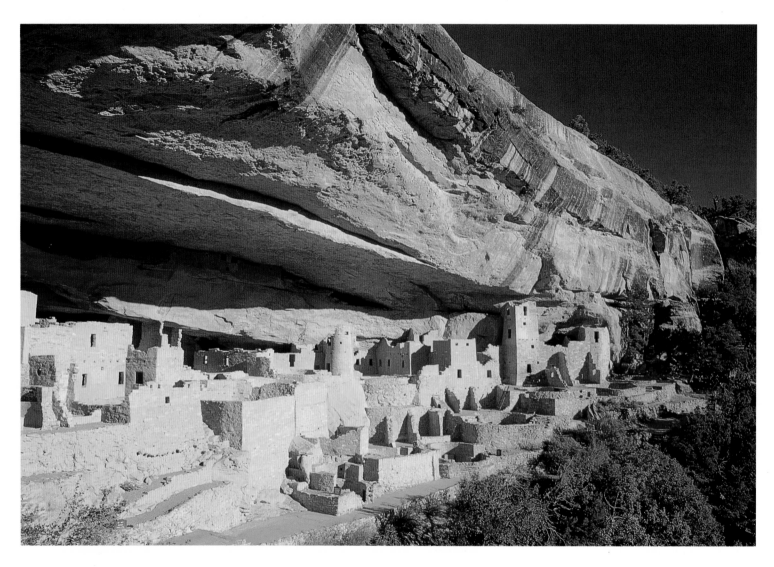

CLIFF PALACE
Anasazi, c. 1200-1300
MESA VERDE NATIONAL PARK, COLORADO

One of the largest and most intriguing of Anasazi cliff dwellings, Cliff Palace
includes 217 rooms and twenty-three kivas.

DETAIL, CLIFF PALACE
Anasazi, c. 1200-1300
MESA VERDE NATIONAL PARK,
COLORADO

*The tale of Richard Wetherill and Charlie
Mason, two Colorado cowboys "just out
lookin' for strays" one snowy December
day in 1888, remains one of the most
romantic stories in archaeology. Peering
across a canyon through the storm, they
were amazed at the sight of Cliff Palace.
Although European Americans had by
that time seen many pueblos, the size
and beauty of this cliff dwelling attracted
international attention. Before its
protection within the national park in
1906, many people came to explore Cliff
Palace, even camping in the ruins and
helping themselves to artifacts. Now
excavated and stabilized, Cliff Palace
dazzles hundreds of thousands of visitors
a year.*

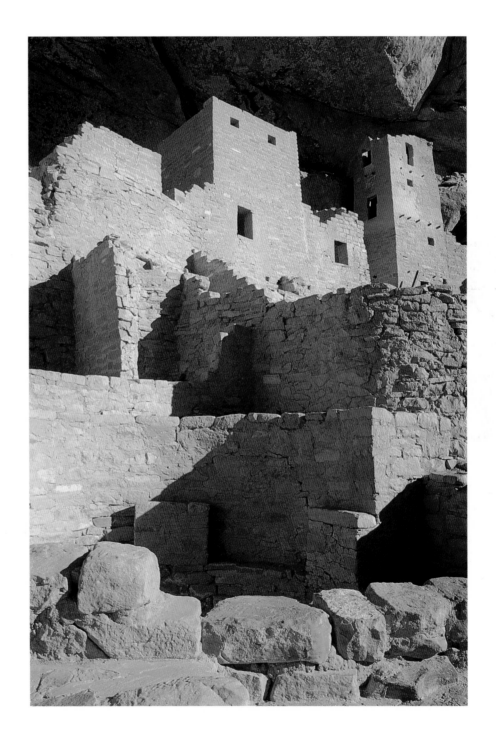

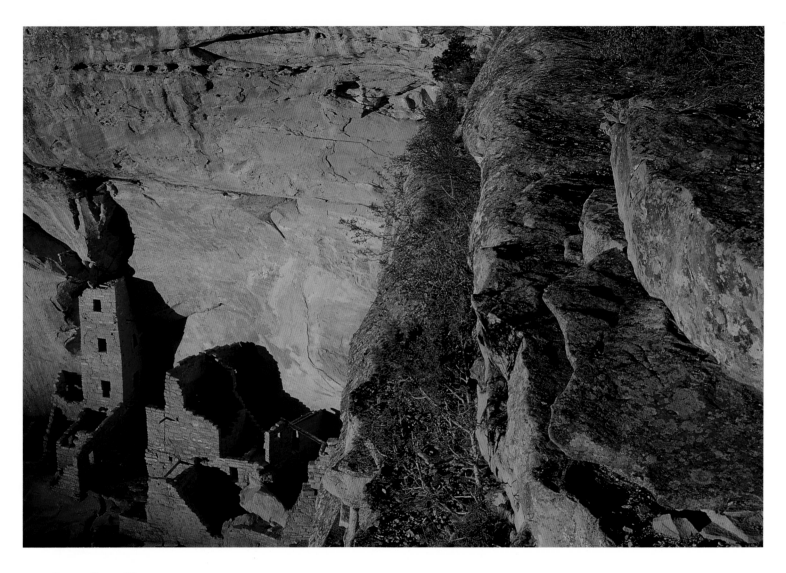

SQUARE TOWER HOUSE
Anasazi, c. 1200-1300
MESA VERDE NATIONAL PARK, COLORADO

Bathed in sunset light, Square Tower House lies sheltered below the mesa's rim. Its courtyards and rooftops were once lively with children, dogs, and turkeys. One might have seen women grinding corn or making pottery and baskets while they looked after their families. Think of harvest time, when the people spread corn, beans, and squash out to dry on the roofs in the sun.

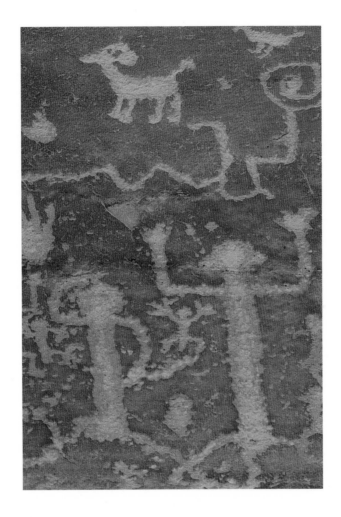

PETROGLYPHS
Anasazi, c. 1200-1300
MESA VERDE NATIONAL PARK, COLORADO

Figures pecked into the rock portray a large bird, a horned quadruped, a human hand, wavy lines, and anthropomorphs with raised arms. Some scholars believe Anasazi petroglyph sites may have been shrines controlled by social or religious groups. The similarities between these petroglyphs and rock art of distant sites testifies to a lively cultural interaction among Anasazi peoples across the Colorado Plateau.

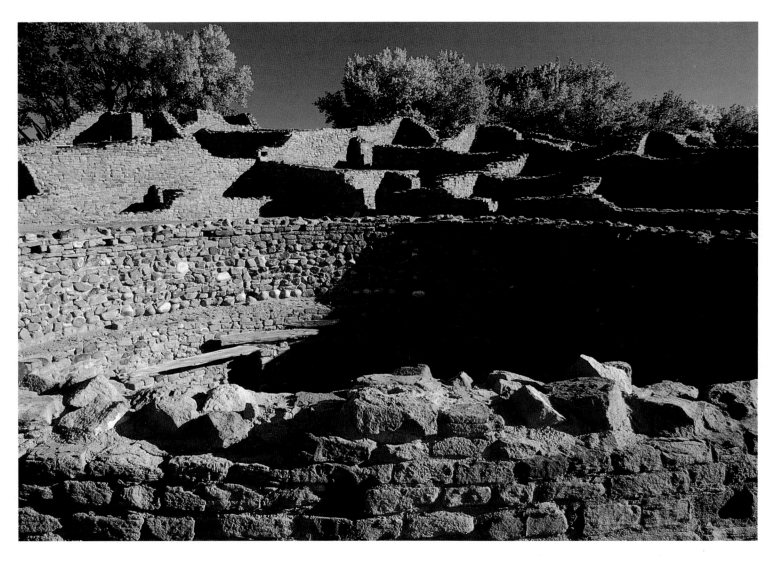

AZTEC RUIN
Anasazi, 1106-1124; remodeled c. 1225
AZTEC RUIN NATIONAL MONUMENT, NEW MEXICO

*In this grand, Chacoan-style pueblo near the Animas River several hundred people lived in hundreds
of rooms on three stories with two dozen kivas, including a magnificent "great kiva," focus of the whole
complex. Yet after fifty years, Aztec was abandoned and lay deserted until about 1225, when Mesa Verde
Anasazi arrived, remodeled, and added to the older pueblo. But by the end of the century, they too had left.*

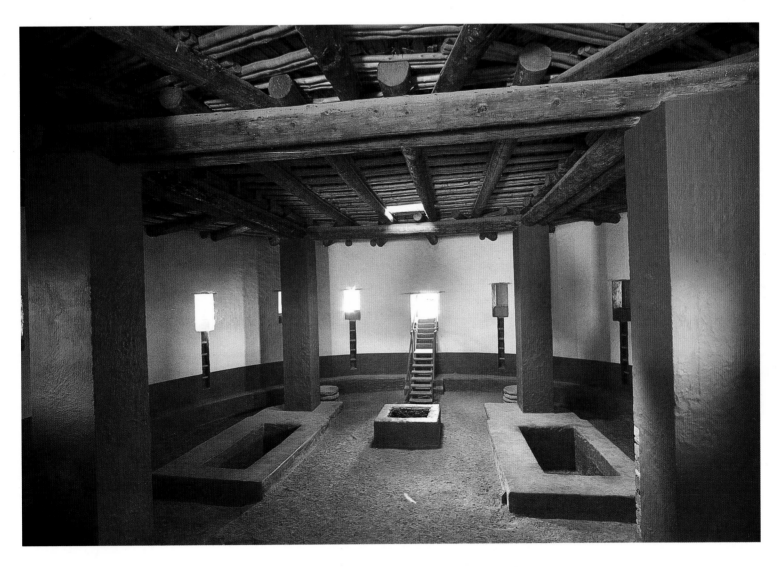

GREAT KIVA
Chaco Anasazi, c. 1175
AZTEC RUINS NATIONAL MONUMENT, NEW MEXICO

*Early Anglo settlers, who thought this enormous complex must belong to the great civilization of Mexico,
gave it the misnomer "Aztec." They took many building stones and artifacts from the ruin. In 1916
archaeologist Earl Morris began a systematic excavation of Aztec; in the 1930s he supervised the restoration
of the Great Kiva, the only such restoration in the Southwest.*

Ceremony of Earth & Sky

Chaco—heart of Anasazi civilization—was built on a spectacular scale. More than 75 carefully engineered structures of up to 600 rooms were connected by a network of roads in a complex, regional system of trade and ceremonial life. Water-control berms and channels made possible extensive farming of the arid valley. Many astronomical alignments have been found at Chaco, both in the buildings and marked by petroglyphs among the tumbled boulders of the surrounding terrain. This was a civilization close to both earth and sky.

The hallmark of Chacoan civilization was the great kiva: huge, elaborate, and central in the arrangement of the pueblo. Elements included a series of niches around the walls, which in some cases held loops of precious shell or turquoise. Encircling benches may have been for people, or, as in some kivas today, only for spirits. Pairs of floor vaults, oriented north-south, made booming drums when covered with planking—and may also have been used to sprout seeds for ceremonies. An antechamber in the north side held an entryway. Here at Casa Rinconada, a hidden entry under steps leads to a spiral of upright stone slabs which could have screened an important figure until the dramatic moment in a ceremony.

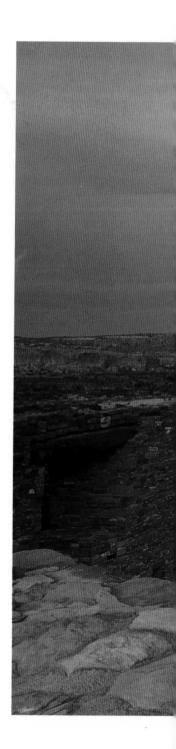

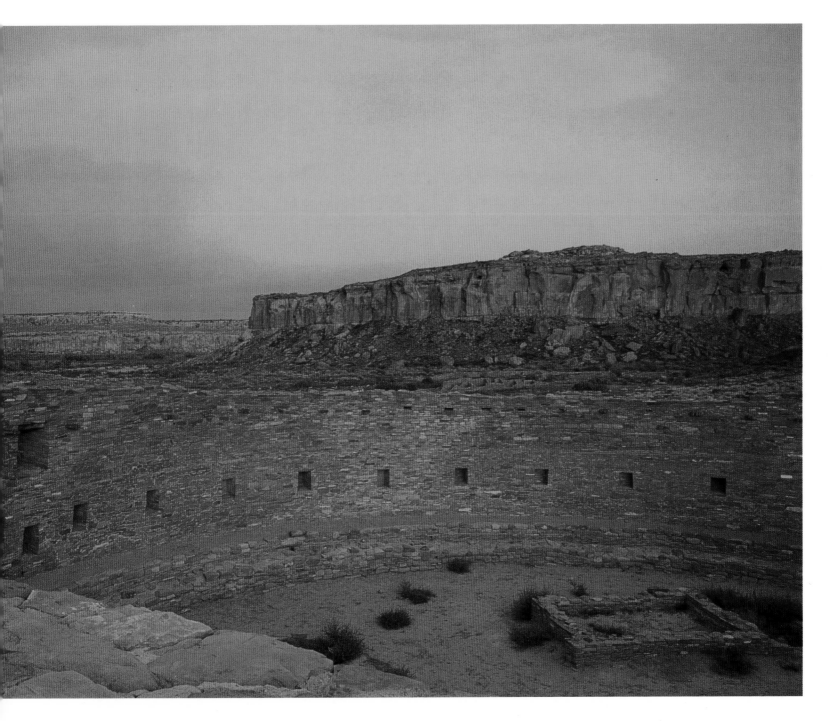

Kiva, Casa Rinconada (Spanish for "House of the Box Canyon")
Anasazi, 11th century
Chaco Culture National Historical Park, New Mexico

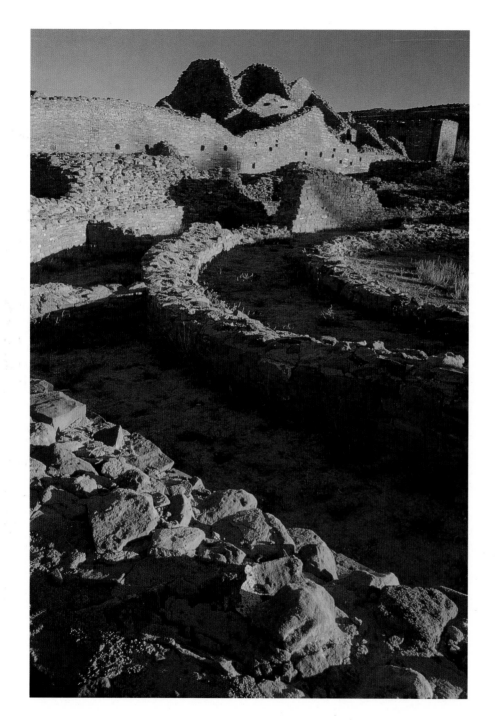

PUEBLO DEL ARROYO
(SPANISH FOR "VILLAGE
OF THE STREAMBED")
Anasazi, c. 1075-1110
CHACO CULTURE NATIONAL
HISTORICAL PARK, NEW MEXICO

*Pueblo del Arroyo's 240 rooms
and over twenty kivas were built in stages.
The use of rubble fill between the finely
shaped stones of the walls' exteriors
enabled the Anasazi to build these walls
as high as four stories. Del Arroyo is
unusual in that the building steps down
to a single story in front, and a three-
walled room adjoins it in the rear.*

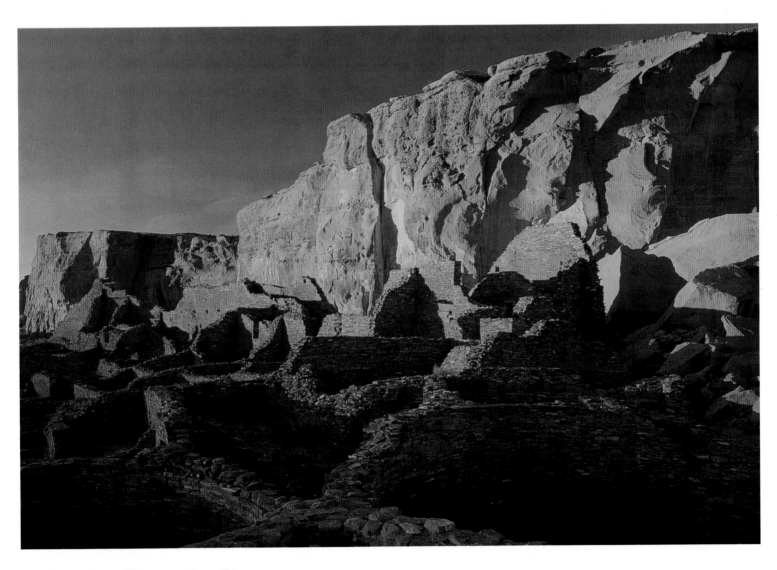

Pueblo Bonito ("Beautiful Village")
Anasazi, c. 900-1200
Chaco Culture National Historical Park, New Mexico

Pueblo Bonito's walls of rough stone were veneered with sandstone quarried from the clifftops. In the 1930s, the National Park Service tried to stabilize Threatening Rock, a thirty-thousand-ton slab of cliff teetering behind the pueblo. (Local Navajos called it "the place where the cliff is propped up" for the Anasazi masonry at its base.) Threatening Rock crashed down on top of sixty-five rooms of the pueblo in 1941. Where the rock once stood, Anasazi pahos, *or prayer sticks, were found.*

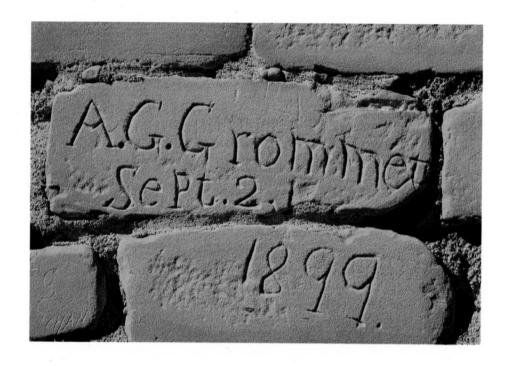

Graffito, Pueblo Alto
(Spanish for "High Village")
Euro-American, 1899
Chaco Culture National Historical Park,
New Mexico

*The difficulty in interpreting ancient rock art
becomes obvious when trying to explain historic
graffiti. Is this the scribbling of a cultural moron?
Or is it a celebration of one man's unique identity
and place in history? Has Mr. Grommet expressed
kinship with the people of the past, or contempt
for them?*

PUEBLO BONITO DOORWAYS
Anasazi, eleventh century
CHACO CULTURE NATIONAL
HISTORICAL PARK, NEW MEXICO

*What happened to the people of Chaco?
Most evidence points to the land's inability
to support a concentrated, urban
population. This haunts the modern
people of the Southwest, whose ambitious
irrigation projects and powerlines snake
across the landscape today just as the
mysterious roads of Chaco did nine
centuries ago. Did the Chacoans foresee
the collapse of their way of life?*

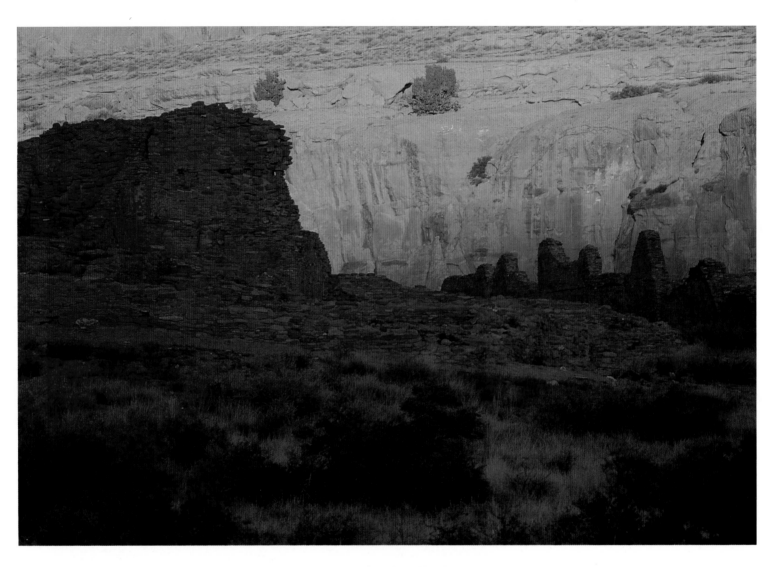

Chetro Ketl (possibly derived from Navajo; meaning has been lost) & Talus Unit I
Anasazi, c. 1038-1054
Chaco Culture National Historical Park, New Mexico

Ancient stairways from Chetro Ketl to the top of the bordering cliffs lead to prehistoric roads, which run straight for miles—despite rugged terrain—to connect dozens of Anasazi sites in the region. More than two hundred miles of roads have been plotted, revealing phenomenal engineering skill and community organization.

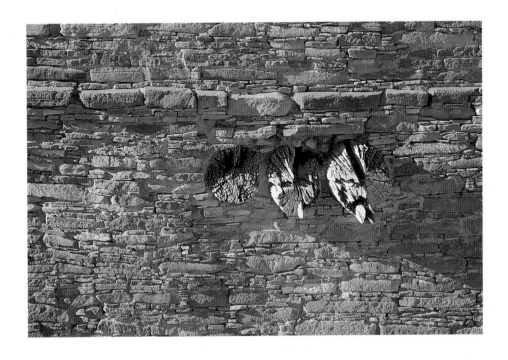

CHETRO KETL, WALL DETAIL
Anasazi, c. 1038-1054
CHACO CULTURE NATIONAL HISTORICAL PARK,
NEW MEXICO

*How do we know when the pueblos were built? Their
vigas, or beams, give us the answer. The trees from
which these beams were made put on a ring of growth
around their trunks every year. In years of drought,
the ring was narrow; in wet years, wide. Astronomer
A. E. Douglass realized that a chart of annual growth
rings could be developed that would "fingerprint"
a beam's place in time.*

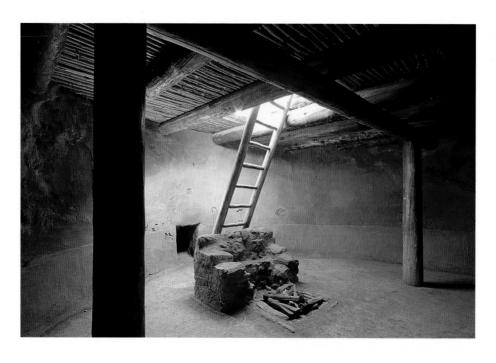

KIVA
Pueblo, post-1680
PECOS NATIONAL MONUMENT, NEW MEXICO

Pecos reflects the ebb and flow of Southwest cultures. By 1450, Anasazi from all over had established Cicuye, a 660-room pueblo on the upper Rio Grande. Traders with Plains people, they wore buffalo hides over traditional cotton clothing. When the conquistador Coronado arrived in 1541, a Plains ally of Cicuye led him eastward, to try and maroon him in Kansas. In the 1620s, Franciscans established a mission at "Pecos" (a name other natives gave Cicuye), introducing cattle and sheep, wheat, metal tools, and adobe blocks as well as their faith.

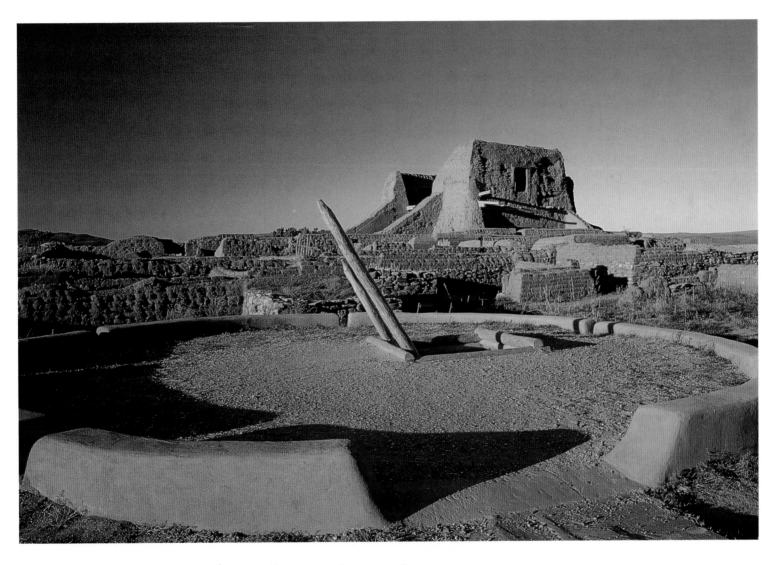

Misión de Nuestra Señora de Los Ángeles de Porciúncula Church and Convento
(Kiva in foreground)
Spanish, c. 1620
Pecos National Monument, New Mexico

The Spanish mission here was burned in the Pueblo Revolt of 1680, and a kiva built among its ruins; the mission was reestablished in 1692. By 1838, the few people who had survived European diseases and war with the Comanche moved to Jemez pueblo, leaving church and pueblo deserted.

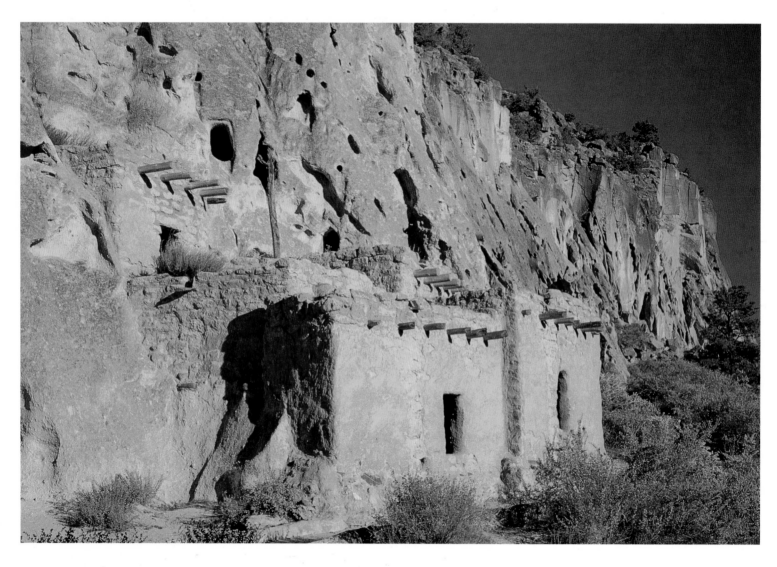

TALUS HOUSE
Anasazi, c. 1200-1300
BANDELIER NATIONAL MONUMENT, NEW MEXICO

Many Anasazi who abandoned their pueblos elsewhere in the Southwest came to the canyon of El Rito de los Frijoles ("Bean Creek" in Spanish) where they found permanent water and enough soil to farm. They built pueblos against the cliffs of soft, compressed volcanic ash, often enlarging cavities in the cliffs to live in as well.

72

TYUONYI
Anasazi, occupied until c. 1550
BANDELIER NATIONAL MONUMENT,
NEW MEXICO

*Tyuonyi, with over three hundred ground-
floor rooms in an oval around a courtyard
holding three kivas, was probably three
stories high. The pueblo was abandoned
shortly after the Spanish came to this area.
The monument is named for Adolph
Bandelier, who at age forty forsook a
comfortable future in Ohio business to
pursue his passion for the natural and
human history of the Southwest. Bandelier
loved Frijoles Canyon, and in addition to
scientific reports wrote an Anasazi novel,*
The Delight Makers, *about it.*

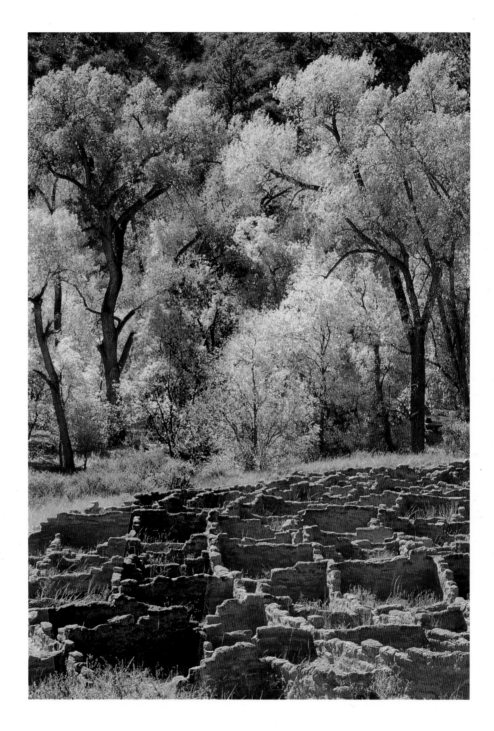

73

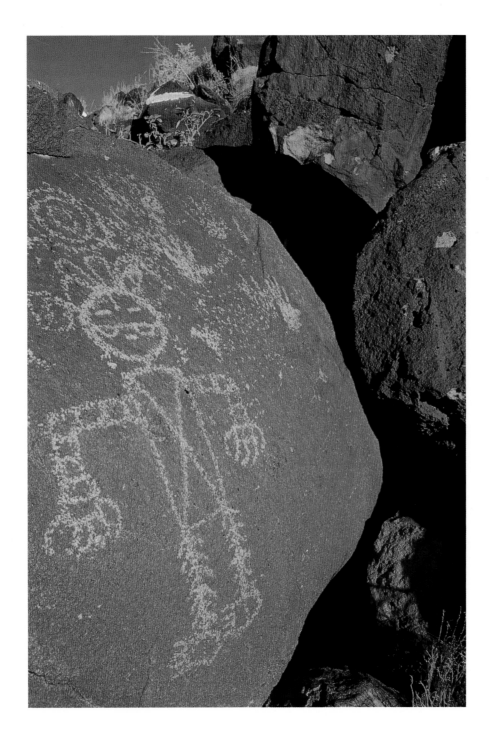

PETROGLYPHS
Rio Grande Style (Pueblo)
c. 1300-1500
PETROGLYPH NATIONAL MONUMENT,
NEW MEXICO

By hammering directly into the patina of the rock—or using a hammerstone with a stone chisel—people have been pecking images onto these boulders for three thousand years. "Rio Grande style" petroglyphs are the work of Anasazi fleeing to this permanent water source from drought elsewhere. The Anasazi maintained their cultural traditions despite their difficulties.

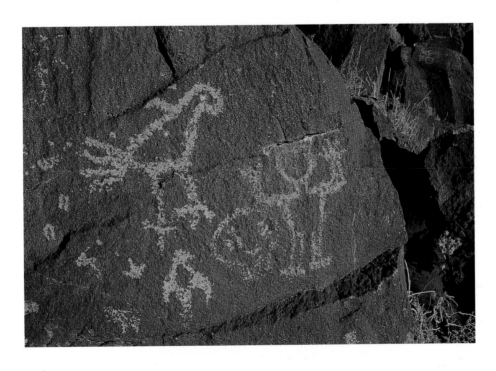

MACAW
Rio Grande Style (Pueblo) c. 1300-1500
PETROGLYPH NATIONAL MONUMENT, NEW MEXICO

The beautiful macaw, long-lived and temperamental,
is still often portrayed in pueblo art. Anasazi of the
Rio Grande traded turquoise from Cerrillos, among
other things, to people of northern Mexico in
exchange for macaws. If such delicate tropical birds
could survive the journey of hundreds of miles from
Chihuahua, what about ideas and stories?

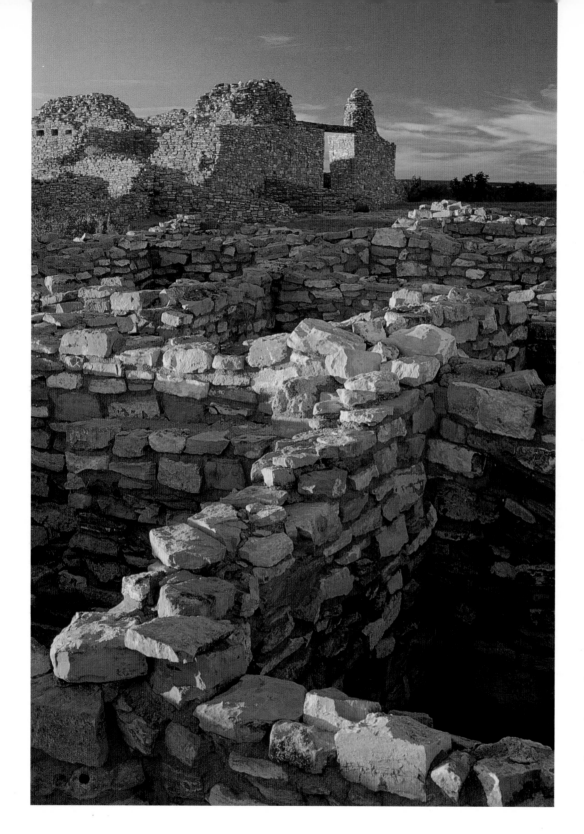

CHURCH OF SAN BUENAVENTURA,
GRAN QUIVIRA
Spanish, 1659
SALINAS NATIONAL MONUMENT,
NEW MEXICO

Salinas *means salt lagoons, a characteristic
of this valley with no exterior drainage.
Never bountiful, the area was nevertheless
well populated with people influenced by
three cultures: Mogollon, Anasazi, and
Plains. After the Spanish came to the
pueblo of Cueloze in 1598, friars intent on
saving Pueblo souls struggled with Spanish
land grantees greedy for native labor and
produce. Although many Pueblos
converted to Christianity—and the
Spanish destroyed their kivas—some still
practiced their old religion in secret.*

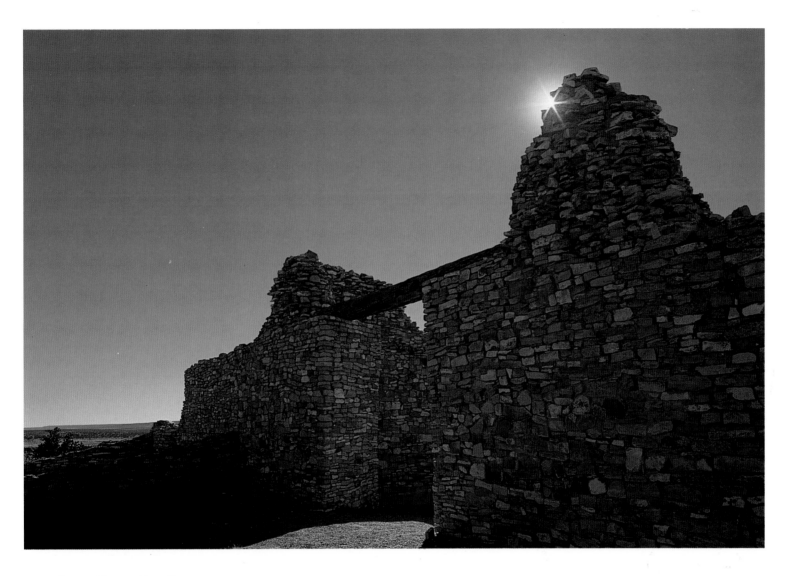

CHURCH FAÇADE, GRAN QUIVIRA
Spanish, 1659
SALINAS NATIONAL MONUMENT, NEW MEXICO

*By 1680, the pueblo of Cueloze (today called Gran Quivira after a mythical city of treasure) had been
abandoned. Trade networks between Pueblo and Apache had disintegrated into warfare under the pressure
of Spanish slave raids, and exploitation together with introduced diseases decimated the Pueblos. The few
who survived moved to villages west of the Rio Grande.*

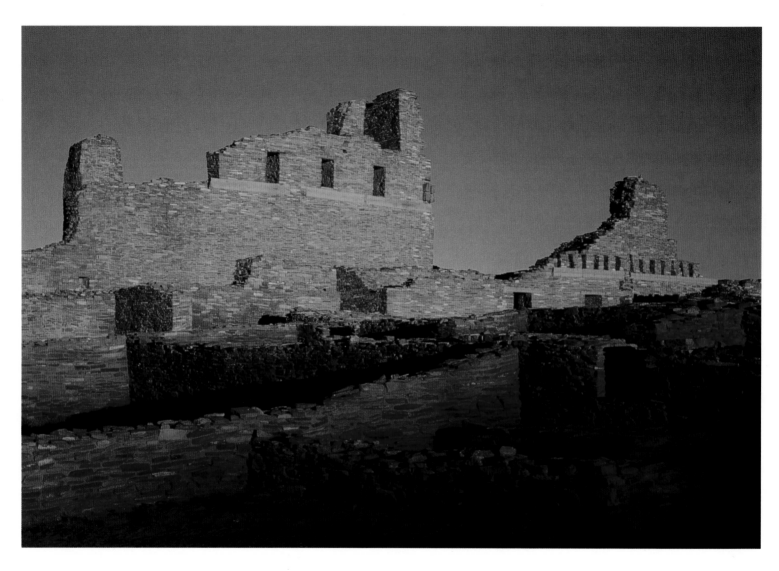

MISIÓN SAN GREGORIO DE ABÓ
Spanish, c. 1626
SALINAS NATIONAL MONUMENT, NEW MEXICO

The Spanish established this mission for a thriving pueblo that lay on a pass into the Rio Grande Valley.
Much of their land was poor for farming, so the resourceful people of the pueblo traded salt for other
commodities to peoples in northern and western New Mexico and east, on the plains. The church built here
was an ambitious one, so massively buttressed that its walls still stand high today.

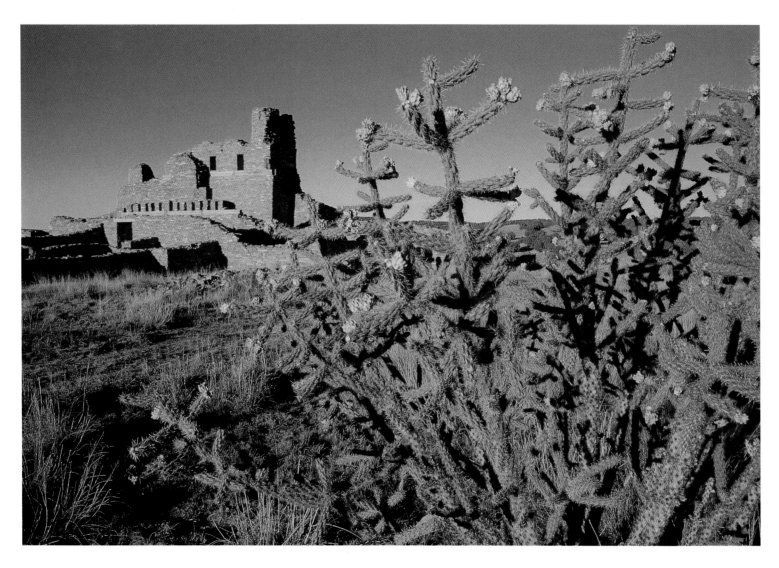

MISIÓN SAN GREGORIO DE ABÓ
Spanish, c. 1626
SALINAS NATIONAL MONUMENT, NEW MEXICO

*During daily masses, a choir accompanied by an organ filled the new sanctuary with hymns. Yet within
fifty years, the church and pueblo lay silent, the friars' dreams dashed by their own impatience and
intolerance. Spanish policy changed after the Reconquest of 1692 to allow the practice of native religions
alongside Christianity, but it was too late for Abó.*

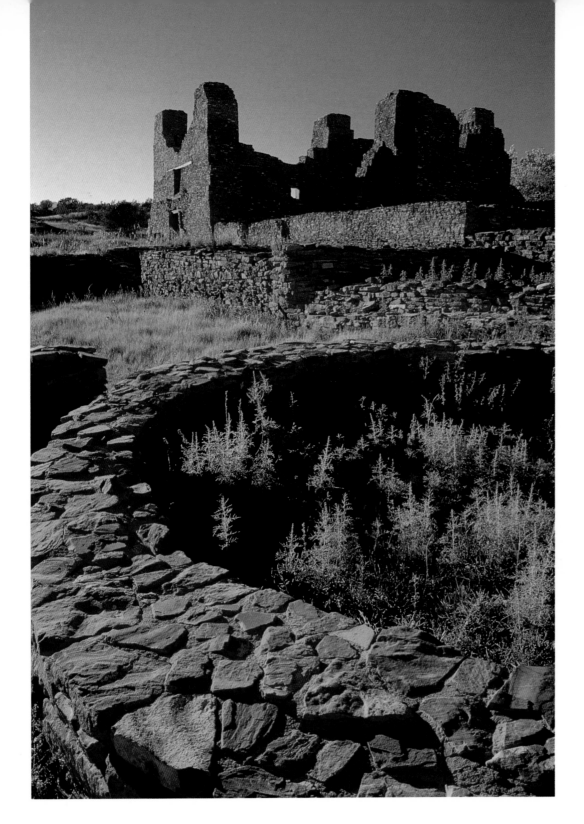

CHURCH OF LA PURÍSIMA
CONCEPCIÓN DE CUARAC, QUARAI
Spanish, 1628
SALINAS NATIONAL MONUMENT,
NEW MEXICO

*This church towered above the
pueblo. Wide doors swung open to
reveal the lofty sanctuary, painted
white with patterns of red, black,
yellow, and blue at waist height.
Dazzling sunlight poured through
a clerestory window to illuminate
an altar decorated with linens and
brass candlesticks. Polychrome
altarpieces carved and painted in
Mexico rose almost to the rafters.
Within the walls of the convento
grew gardens of flowers, vegetables,
and fruit trees.*

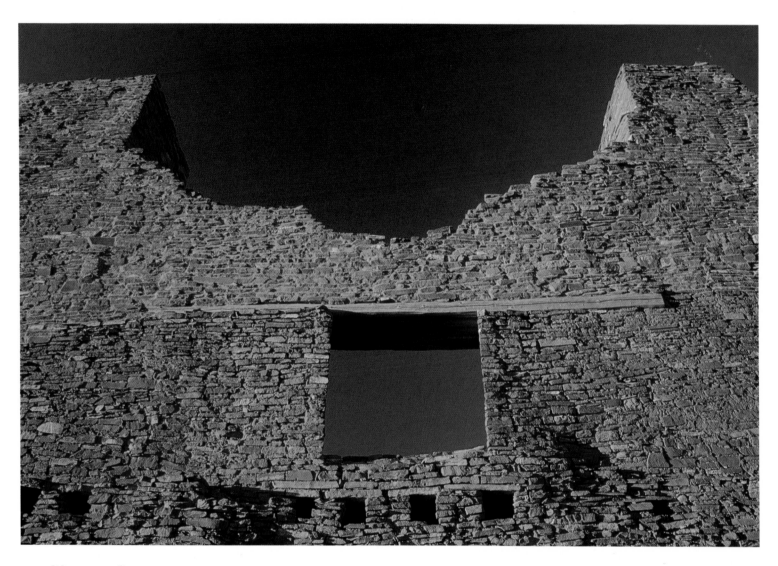

WALL DETAIL, QUARAI
Spanish, c. 1628
SALINAS NATIONAL MONUMENT, NEW MEXICO

From long days of labor—each stone cut and placed by hand—rose this beautifully crafted wall. Records show that drought in the 1660s led to the abandonment of Quarai—the pueblo and its imposing mission church—over the next decade.

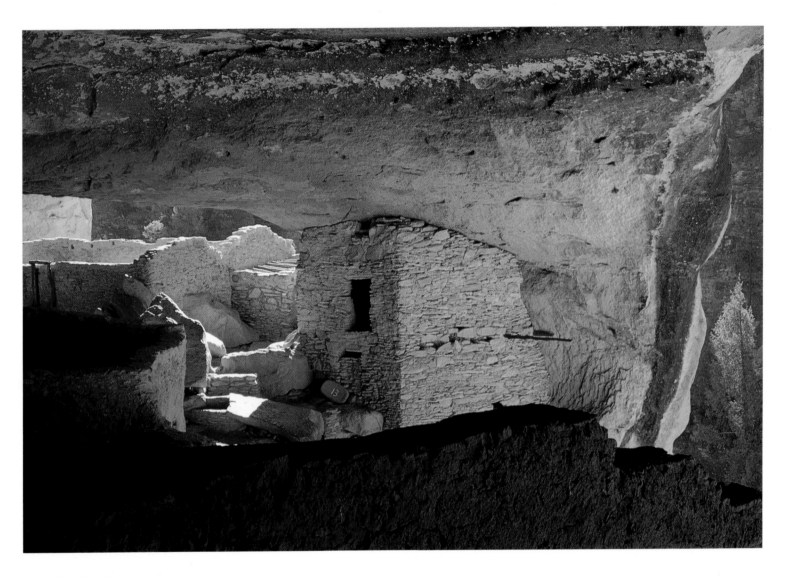

GILA CLIFF DWELLINGS
Mogollon, c. 1280
GILA CLIFF DWELLINGS NATIONAL MONUMENT, NEW MEXICO

This cliff dwelling's filled-in doorway is typical of the modifications often made in the stone villages of the Southwest as populations grew and declined. The Mogollon people lived in this area for a thousand years or more in simple pithouses dug below ground and later built above ground of masonry or adobe. After the cliff-dwelling Anasazi moved into their territory, the Mogollon learned to build these houses in shallow caves.

WEST FORK, GILA RIVER
GILA CLIFF DWELLINGS NATIONAL
MONUMENT, NEW MEXICO

*After the Mogollon left, this rugged
country became the home of nomadic
Apache people; historians say the river's
name is a Spanish version of the Apache
word for mountain. They lived on the rich
resources of mountains and streams
throughout much of the Spanish and
American colonial periods, but took to
raiding ranches and retreating to remote
canyons in the nineteenth century. The
U. S. military made war on the Apaches,
finally bringing them under submission
in 1886.*

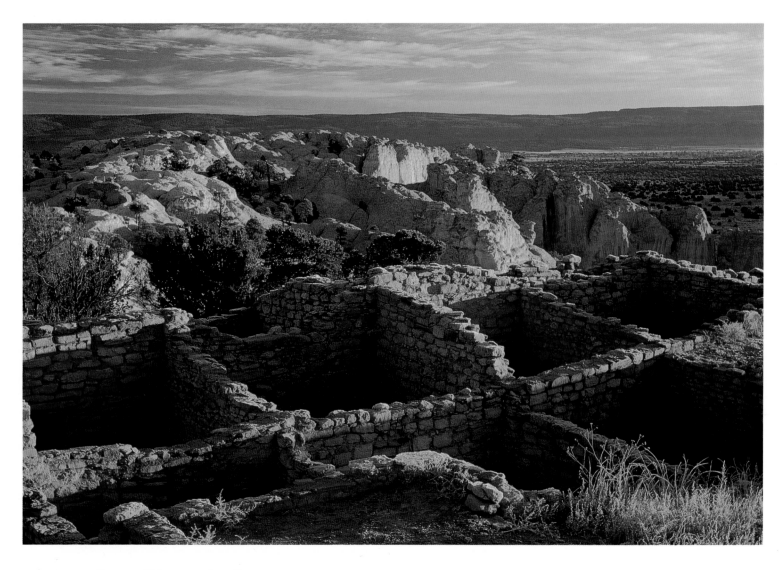

ATSINNA (ZUNI FOR "WRITING ON ROCK")
Zuni, thirteenth & fourteenth centuries
EL MORRO NATIONAL MONUMENT, NEW MEXICO

El Morro *is Spanish for bluff. Pueblo people built two villages on the blufftop, two hundred feet above the valley floor. Atsinna was huge, its thousand rooms arranged in tiers up to three stories around a central plaza, commanding a view in all directions for many miles. Many scholars see no break between the Chaco Anasazi culture and Zuni pueblo villages such as Atsinna.*

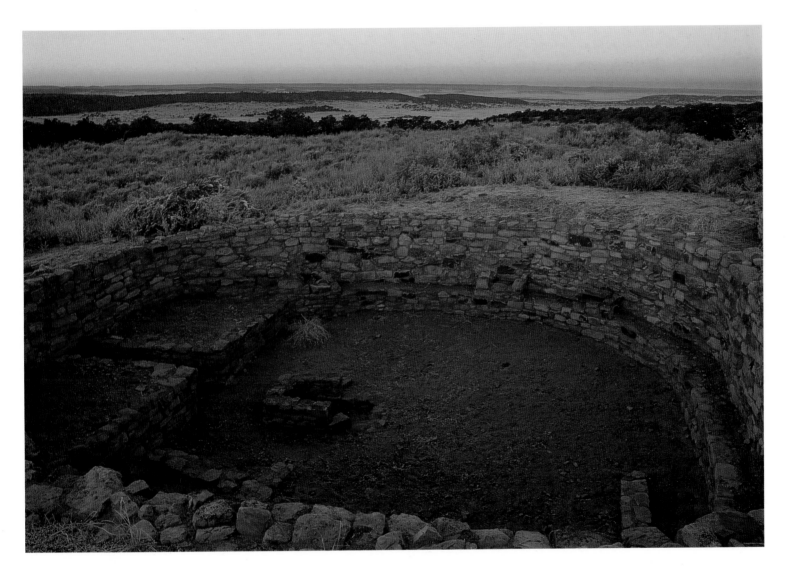

KIVA AT ATSINNA
Zuni, thirteenth & fourteenth centuries
EL MORRO NATIONAL MONUMENT, NEW MEXICO

The Zuni depended upon a pool at the base of El Morro for water and grew crops in the surrounding valley. But this is dry country, the growing season short. They must have performed countless prayers and ceremonies in this kiva to bring rain and a successful harvest. Eventually, they gave up. Atsinna's people moved west, to communities on the Zuni River.

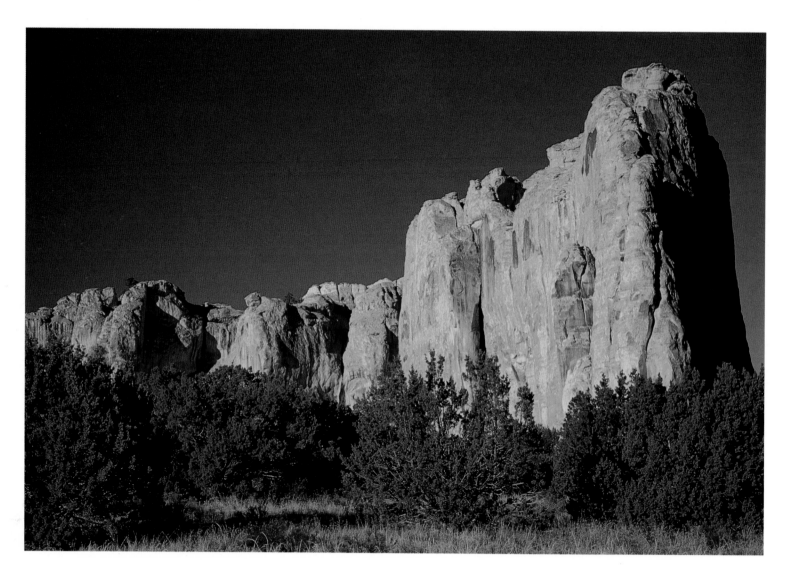

INSCRIPTION ROCK
EL MORRO NATIONAL MONUMENT, NEW MEXICO

A natural basin below the looming sandstone monolith fills with rain and melted snow, offering refreshment for sunstruck travelers. Many have left a sign of their passing on the rock. Pueblo petroglyphs number in the hundreds; early Spanish inscriptions note the efforts of priests and soldiers to bring local people under their control. Finally, soldiers of the U. S. Army, emigrants, traders, surveyors, and Indian agents left their names here.

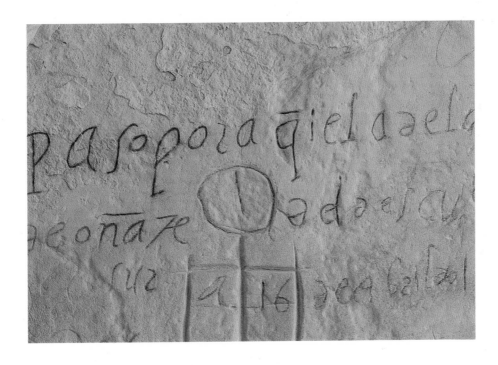

OÑATE INSCRIPTION
INSCRIPTION ROCK
EL MORRO NATIONAL MONUMENT, NEW MEXICO

Paso por aquí el adelantado Don Juan de Oñate del descubrimiento de la mar del sur a 16 de Abril de 1605.

"Governor Don Juan de Oñate passed by here from the discovery of the southern sea on the 16th of April, 1605." Oñate, first governor of New Mexico, was returning from a journey to the Gulf of California. Records show he passed El Morro for the first time in 1598, seven years before Jamestown, the first English settlement in North America, was founded.

Harmony in the Canyon

At Canyon de Chelly a wonderful harmony exists between landforms and architecture. Tawny sandstone cliffs streaked with desert tapestry seem to billow like canvas above the green canyon floor. Anasazi of the thirteenth century fitted exquisite pueblos into alcoves just above the canyon bottom.

The name Chelly *derives from* tsegi, *the Navajo word for rocky canyon. Today, Navajo hogans of earth and wood dot the streamsides. In spring, Navajo families move down to these homes in the canyon to plant corn and tend their livestock. People have lived in this Eden for perhaps twenty centuries.*

In the mid-1700s, Navajos from New Mexico moved to the Canyon de Chelly area. When they raided nearby villages, the Spanish army pursued them. In 1805, soldiers trapped many Navajos in a Canyon de Chelly rock shelter, killing 115 of them. After the United States took over the region, Colonel Kit Carson waged a scorched-earth campaign against the Navajo, capturing many in Canyon de Chelly in 1864. All Navajo were exiled from their homelands at that time, but four years later they negotiated their return.

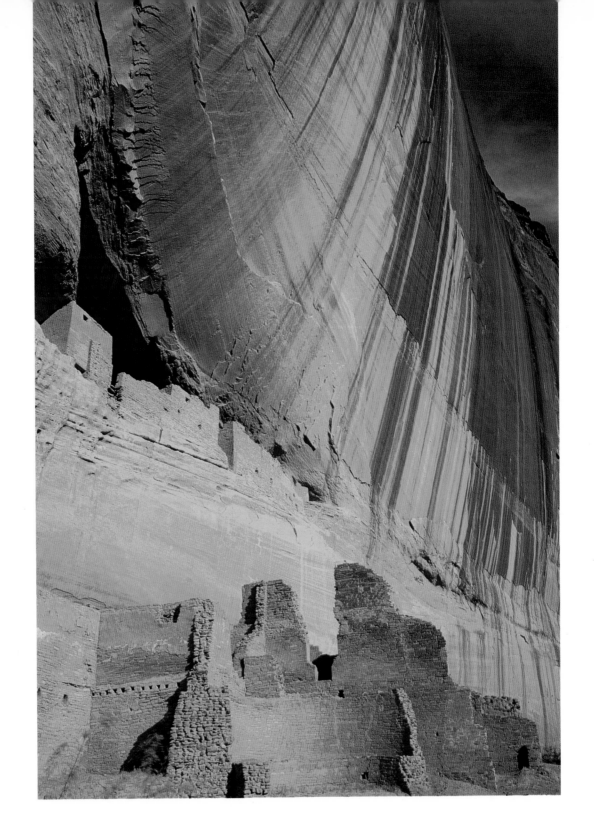

WHITE HOUSE
Anasazi, c. 1050 (lower ruin);
c. 1200 (upper ruin)
CANYON DE CHELLY NATIONAL
MONUMENT, NAVAJO NATION,
ARIZONA

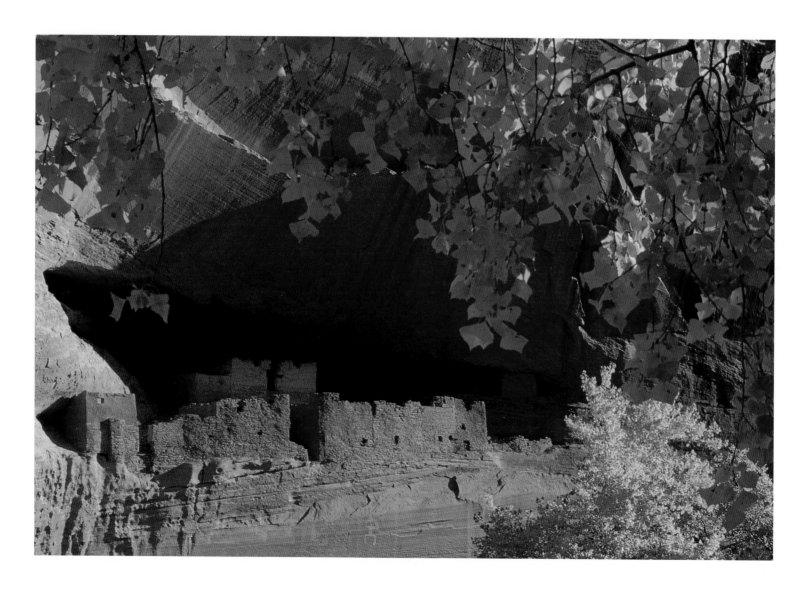

WHITE HOUSE
Anasazi, c. 1200
CANYON DE CHELLY NATIONAL MONUMENT, NAVAJO NATION, ARIZONA

*A sheer wall below and a huge, curving expanse of rock above protected this whitewashed dwelling
in its sheltered riverside alcove.*

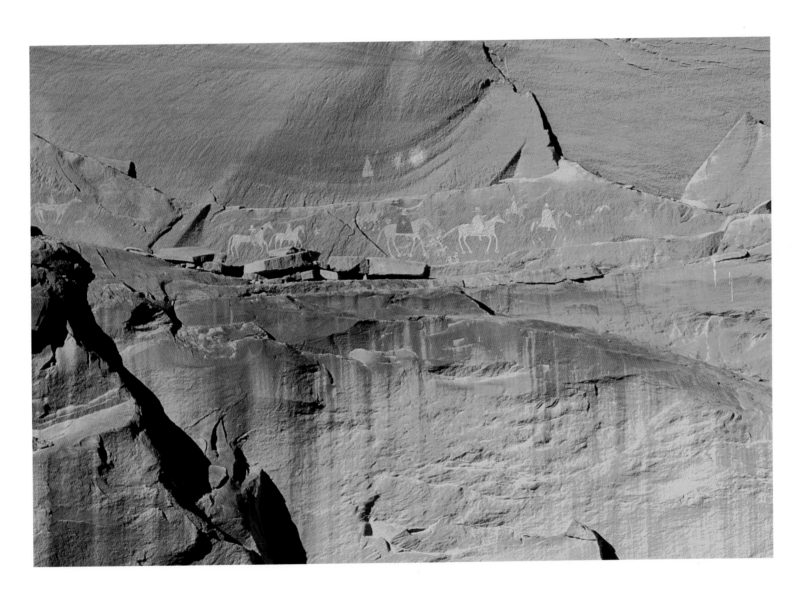

Pictographs, Standing Cow Ruin
Navajo, nineteenth Century
Canyon de Chelly National Monument, Navajo Nation, Arizona

*This painting, thought to be by Dibé Yázhí Nééz (Tall Lamb), a Navajo who lived here during the 1805
Spanish massacre, depicts mounted soldiers armed with flintlock guns.*

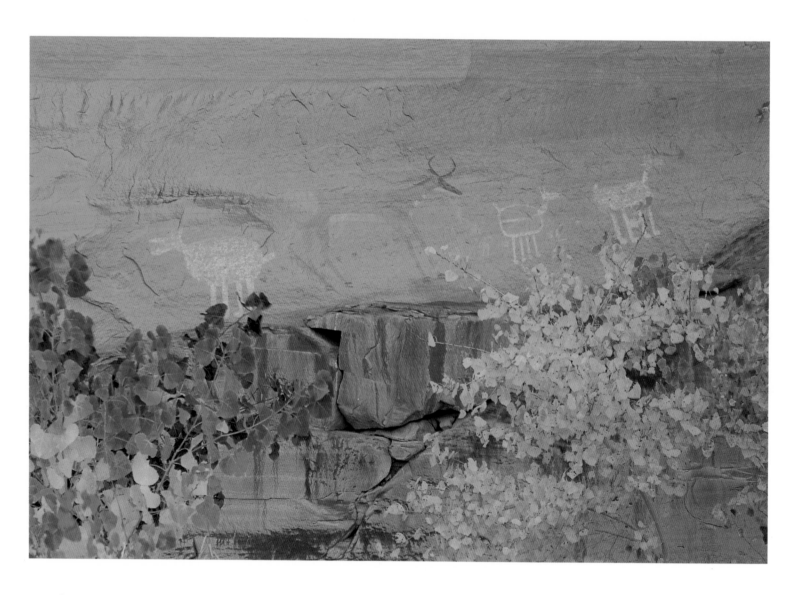

PICTOGRAPHS, ANTELOPE HOUSE
CANYON DE CHELLY NATIONAL MONUMENT, NAVAJO NATION, ARIZONA

Golden aspen leaves flutter below a splendid pictograph of a pronghorn (which is not a true antelope). Until recently, pronghorns were common on the grasslands of the Southwest. They are remarkably swift and farsighted animals, difficult to hunt—yet the Anasazi managed it. Other quadrupeds on the panel are not nearly so artfully drawn as the "antelope"; they appear to have been done at a different time.

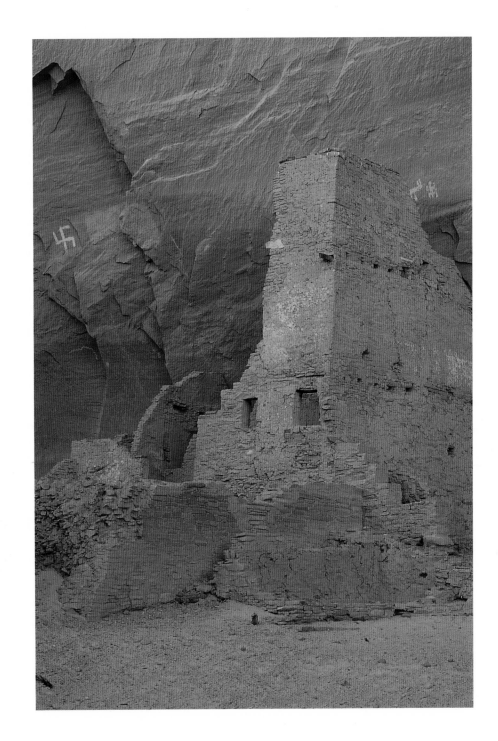

ANTELOPE HOUSE
Basketmaker through Anasazi
CANYON DE CHELLY NATIONAL
MONUMENT, NAVAJO NATION, ARIZONA

*Don P. Morris directed the excavation
of Antelope House from 1970-1973.
Finds showed this site occupied from
the eighth through the thirteenth centuries.
Modern archaeological methods revealed
considerable minutiae concerning
everything from the climate during
occupation to the particulars of Anasazi
diet. After finishing the research project,
archaeologists stabilized Antelope House.*

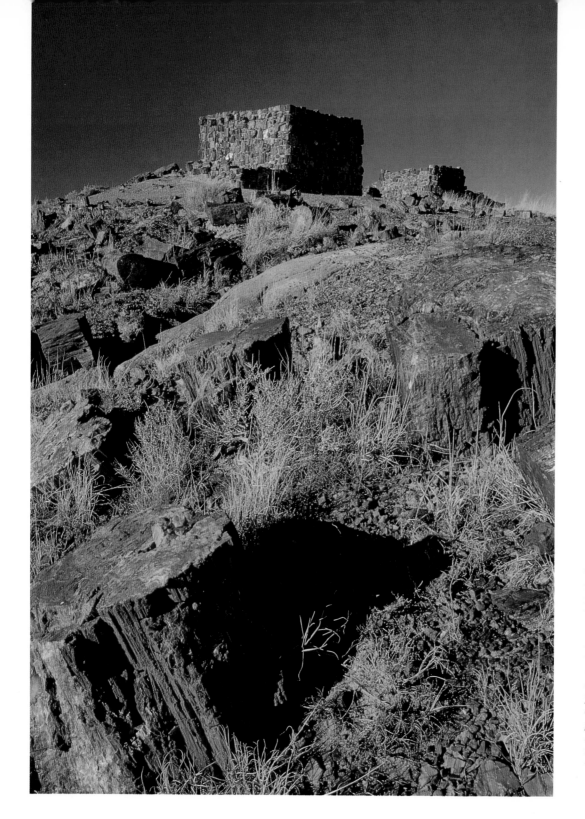

AGATE HOUSE
Anasazi, c. 1100-1300
PETRIFIED FOREST NATIONAL
PARK, ARIZONA

*This eight-room pueblo is one of
several in the area built of petrified
wood set in mud mortar. Fallen
trees buried in a muddy
environment about 220 million
years ago altered to multicolored
quartz as silicon-rich water
percolated through them. We don't
know whether the Anasazi realized
their building blocks resembled
wood.*

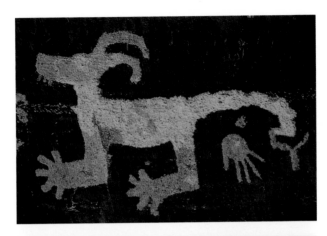

PETROGLYPHS
Anasazi
PETRIFIED FOREST NATIONAL
PARK, ARIZONA

*The geometric petroglyph resembles
the pattern of a woven textile or
basket. What is the quadruped—
a pronghorn? Pronghorns don't
have toes or long tails. A coyote?
The ears aren't right. These people
observed nature carefully. What
did they mean by this creature?*

Watching the Horizon

Puerco *(Spanish for dirty) takes its name from the muddy Puerco River. At first, only about sixty people lived at Puerco and abandoned it after a few generations. After a severe drought struck the region, a much larger population resettled this pueblo, probably because of its proximity to the river. Yet when the rains returned, they came in torrential storms that eroded away the farmlands. The people moved north, to the Hopi mesas.*

Puerco lies on a knoll, its base richly decorated with petroglyphs. These include a "solar observatory" or spiral—a shaft of sunlight illuminates the spiral's center on the summer solstice. In this land of infinite horizons, the sky is an animate presence, one which farming people watch closely.

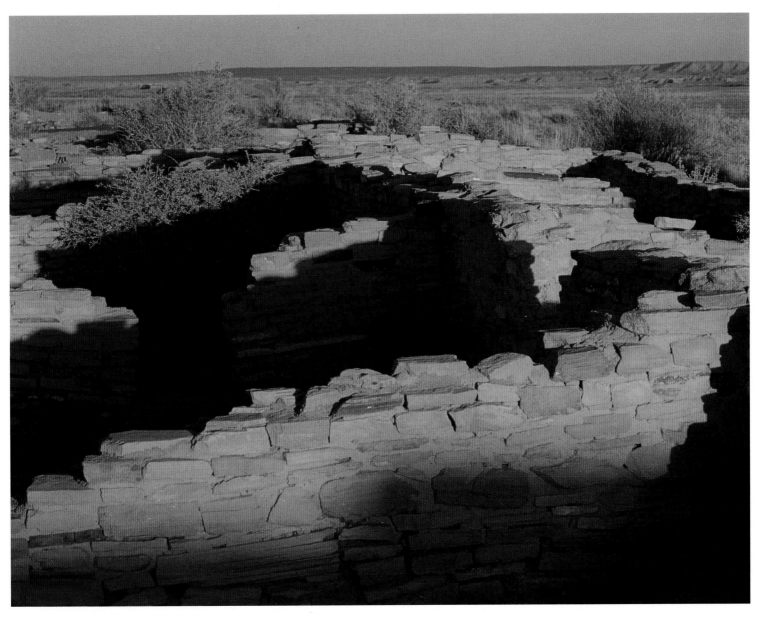

Puerco Ruin
Anasazi, twelfth century; reoccupied thirteenth century
Petrified Forest National Park, Arizona

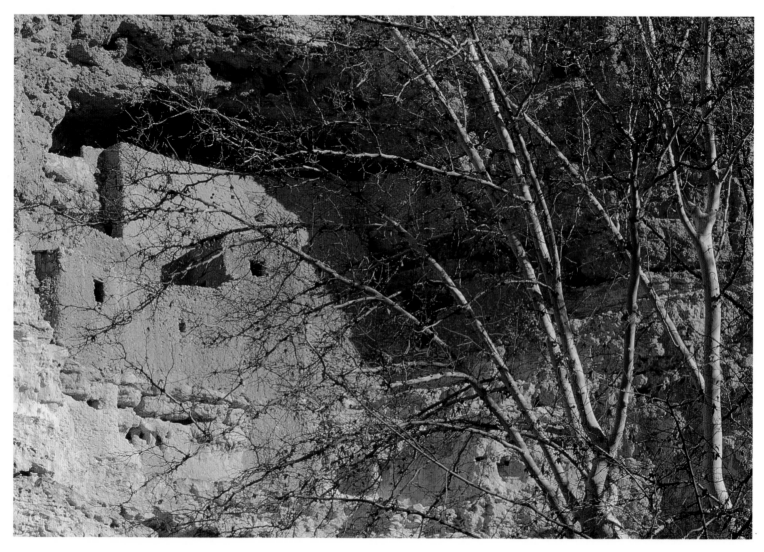

MONTEZUMA CASTLE
Sinagua, twelfth century
MONTEZUMA CASTLE NATIONAL MONUMENT, ARIZONA

When the Sinagua (Spanish for "without water") people moved down into the Verde Valley from the foothills and plateau, they built huge pueblos along the streams at regularly spaced intervals. Archaeologists speculate this was a highly organized way of distributing the resources found at different elevations along the watercourses. Anglo settlers assumed that Montezuma's Aztecs must have built these sophisticated "castles."

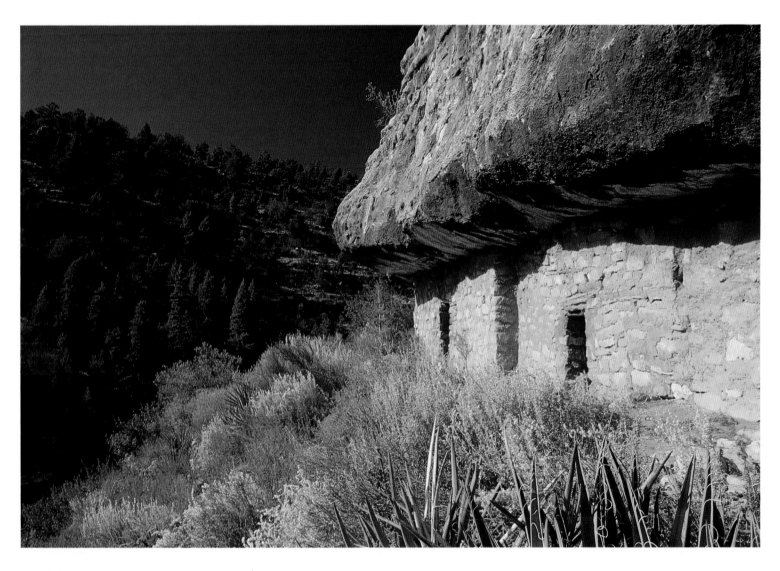

WALNUT CANYON
Sinagua, twelfth century
WALNUT CANYON NATIONAL MONUMENT, ARIZONA

Roofs blackened with smoke, the little cottages of Walnut Canyon present a charming portrait of Sinagua life in the uplands. The people built their rooms below south- and east-facing canyon rims, to be warmed in winter by the low rays of the sun. Pueblos on isolated ridges, formerly called "forts," are now understood to have been community rooms for ceremonies or trading.

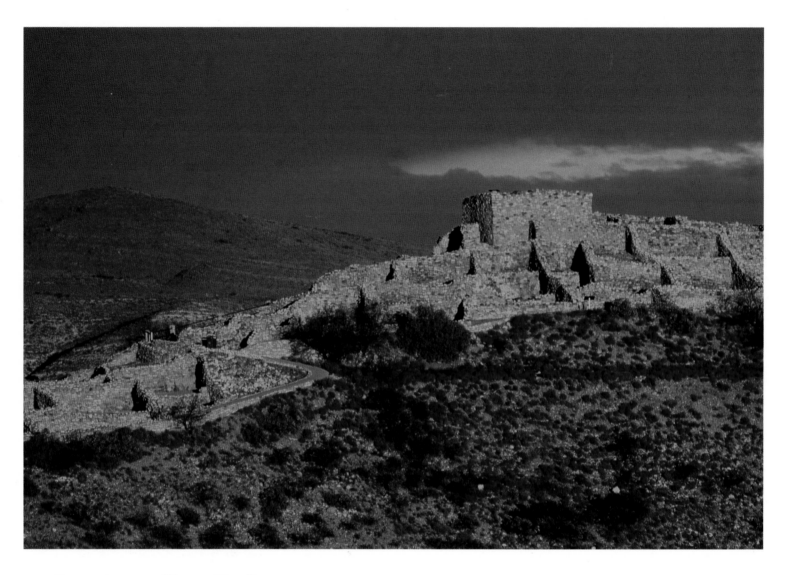

TUZIGOOT (APACHE FOR "CROOKED WATER")
Sinagua, c. 1125-1400
TUZIGOOT NATIONAL MONUMENT, ARIZONA

From its hill at a bend in the Verde River, Tuzigoot commands a sweeping vista of the Verde Valley's fertile farmlands. The Verde Valley was an important trade and migration corridor in prehistory, a thriving melting pot of cultures. Why did the Sinagua abandon it in the early fifteenth century? Current speculations include overuse of the land and conflicts with an incoming, hunter-gatherer culture called the Yavapai.

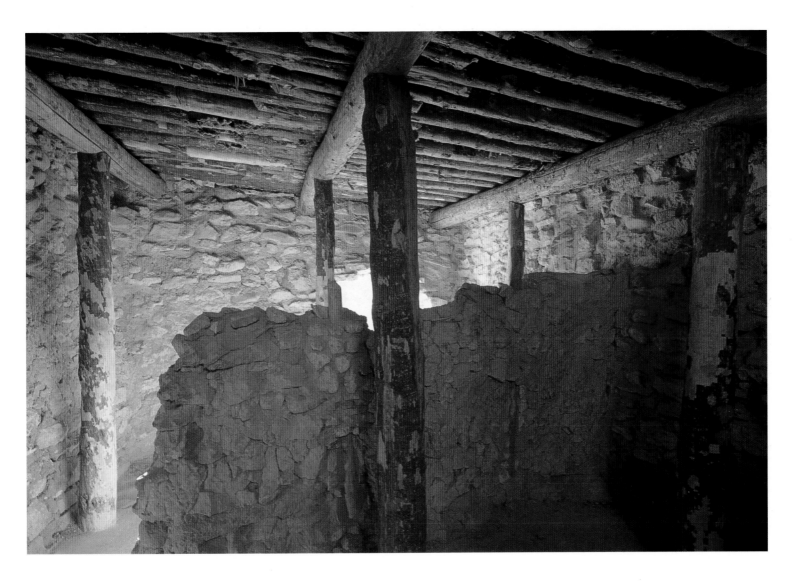

Tuzigoot
Sinagua, c. 1125-1400
Tuzigoot National Monument, Arizona

The Hopis tell their own Tuzigoot story: People were so secure, content, and well fed they neglected their responsibilities, pursuing pleasure instead. The clouds gathered and it began to rain—so much that the farmlands drowned. The people walked north to settle on the Hopi mesas. Several Hopi clans today trace their lineage back to the Verde Valley where a trail, still used in the 1940s, leads to the Hopi mesas.

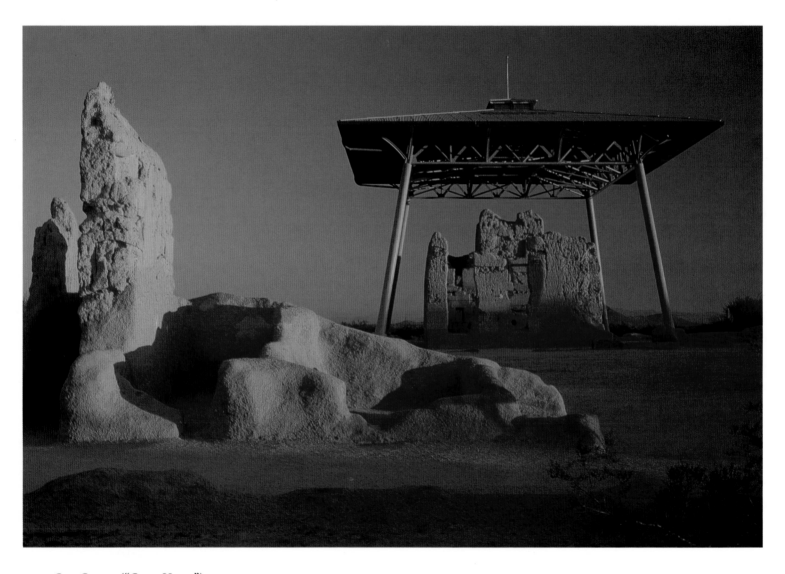

CASA GRANDE ("GREAT HOUSE")
Hohokam, c. 1300-1450
CASA GRANDE NATIONAL MONUMENT, ARIZONA

Hohokam is the name their descendants, the O'odham, use to refer to "those who have gone." The Hohokam piled up stiff mud, without forms or molds, to build walls four stories high and over four feet thick at the base. They brought pine, fir, and juniper roofbeams from miles away, and ground up caliche *(desert debris cemented with calcium carbonate) to make plaster. Inside, they built sixty rooms, laying poles, saguaro cactus ribs, and reeds across the walls to support mud ceilings.*

CASA GRANDE, WALL DETAIL
Hohokam, c. 1300-1450
CASA GRANDE NATIONAL MONUMENT, ARIZONA

Casa Grande may have been a ceremonial or administrative center for the smaller Hohokam dwellings that surround it—some small openings in the walls align with the sun during equinoxes. Early accounts describe remains of an elaborate Hohokam irrigation system with over six hundred miles of canals, but much of this evidence has been obliterated. Many believe the Hohokam culture came to this area from Mexico as early as 300. They left Casa Grande about 1450.

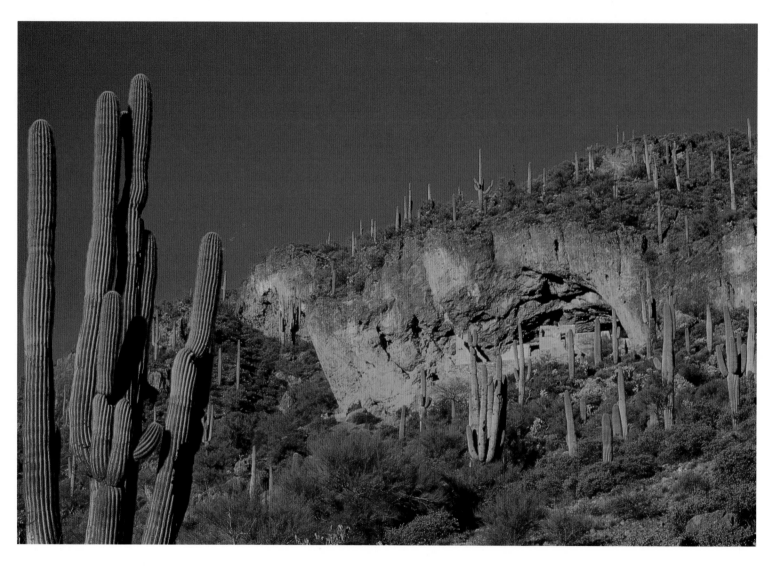

LOWER RUINS
Salado, fourteenth century
TONTO NATIONAL MONUMENT, ARIZONA

*Salado culture (named for the Salado, or Salt River) developed around 1150 from Hohokam roots
established in the Tonto Basin four centuries earlier. The Salado were good farmers, and their population
increased. After many moved to cliff dwellings such as this in the foothills, they specialized in weaving cotton
cloth and making fine pottery for trade to the valley in exchange for food crops and raw cotton.*

TONTO POLYCHROME JAR
Tonto, c. 1400
TONTO BASIN, ARIZONA
MUSEUM OF NORTHERN ARIZONA COLLECTION

Most of us would consider life in the prehistoric Southwest a harsh, minimal existence. Yet in many ways, the people of prehistory expressed joyful spirits and lively imaginations. This pot would not hold its contents any more effectively because it was gracefully shaped and beautifully painted, but these Stone Age people often took the time and trouble to make lovely things.

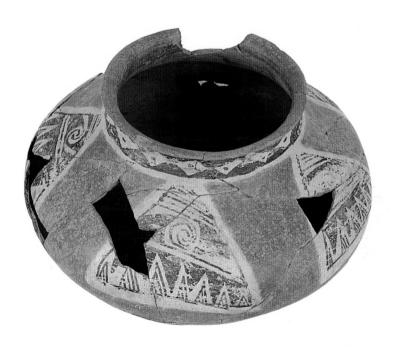

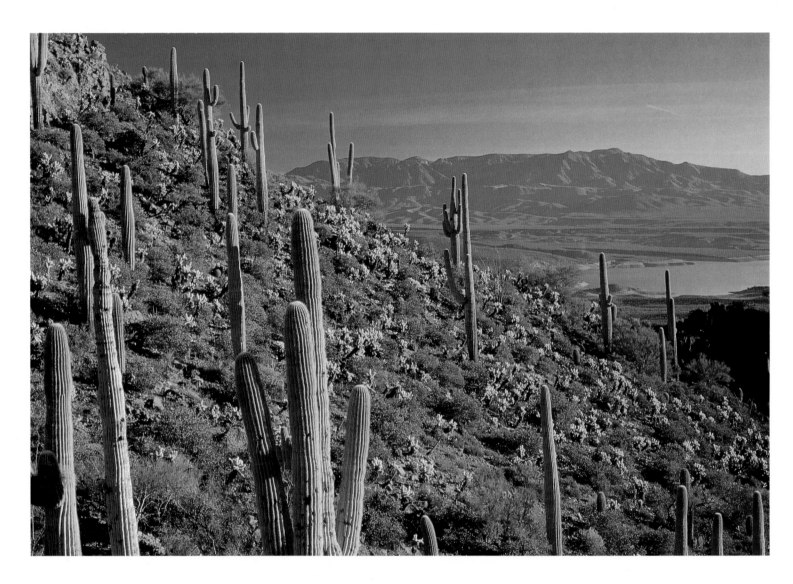

Saguaro Cactus & Roosevelt Lake, from
Tonto National Monument, Arizona

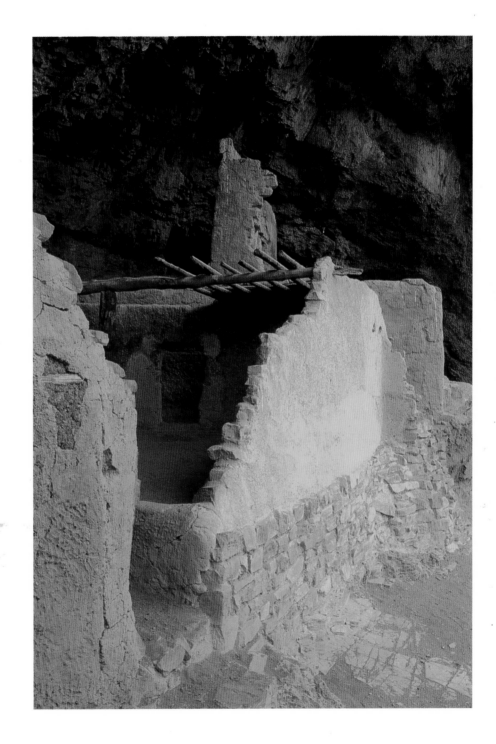

LOWER RUINS
Salado, fourteenth century
TONTO NATIONAL MONUMENT, ARIZONA

Tonto, *the Spanish word for stupid,*
was apparently first applied to a band of
Apaches who lived in this region; it has
since been given to many nearby places. As
we learn more about the remarkable pre-
European cultures of the Southwest, the
name becomes ever more ironic.

Roosevelt Lake, the product of Roosevelt
Dam, has drowned ancient Salado canals,
impounding water for a larger distribution
system that irrigates cotton, alfalfa, and
metropolitan Phoenix. One of the earliest
federal water projects in the West,
Roosevelt Dam was a radical departure for
people who once scorned government help.
When construction of the dam began in
1906, the threat of vandalism to the
nearby Salado cliff dwellings increased.
President Theodore Roosevelt established
Tonto National Monument in 1907 to
give them federal protection.

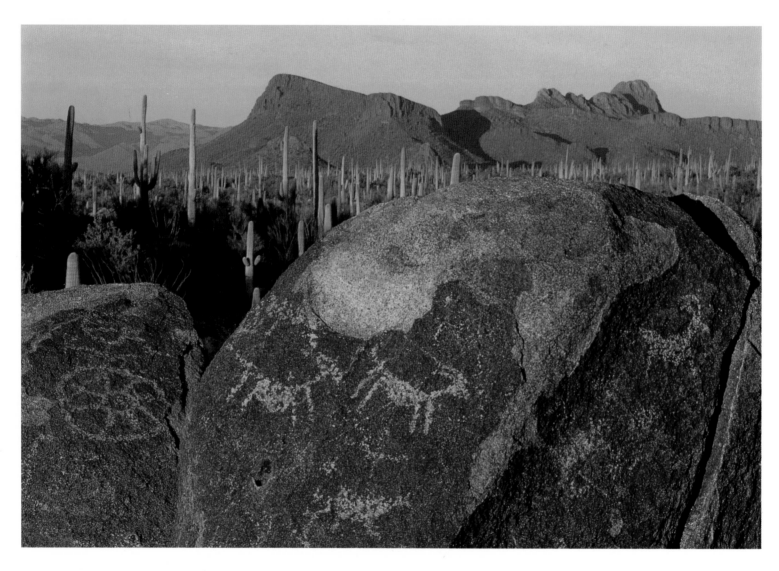

PETROGLYPHS
Attributed to Hohokam, c. 900-1300
SAGUARO NATIONAL MONUMENT, ARIZONA

*The Hohokam did not build great houses near where these particular petroglyphs lie, but rather made
small, temporary camps. Archaeologists believe they came to this area just for hunting, gathering wild foods,
and perhaps ceremonies. Cottontails, jackrabbits, and javelinas (a kind of wild pig) are plentiful here.
Prehistoric hunters would also have found desert bighorn sheep and could gather the fruits of cactus.*

SAGUARO CACTUS
SAGUARO NATIONAL MONUMENT, ARIZONA

Saguaro cactus are extraordinary. The O'odham consider them to be human in more than shape. Saguaro seedlings need the shelter of "nurse" plants to survive. When they are about a century old, they sprout arms and begin to flower. Saguaros are enormous, sometimes fifty feet high and weighing eight tons. The Hohokam ate the fruits and used ribs of dead saguaros for building. Archaeologist Emil Haury determined that they also made a vinegar from the fruit and used it to etch designs in seashells.

OBSERVING THE NATURAL WORLD

Carle Hodge writes that the Tohono O'odham sing to the saguaros:

> *The tall mothers stand there*
> *The tall mothers stand there*
> *Whitely they flower*
> *Black the blossoms dry*
> *Red they ripen.*

Who can say how old this song may be? It is sung by the descendants of the Hohokam; perhaps the Hohokam sang it, too. In any case, it is clear that the people of prehistory felt for the beings of the earth, whether animal or plant, stone or stream. They observed the natural world carefully in order to survive. In doing so, they themselves blossomed as human beings: exuberant, creative, and peaceable.

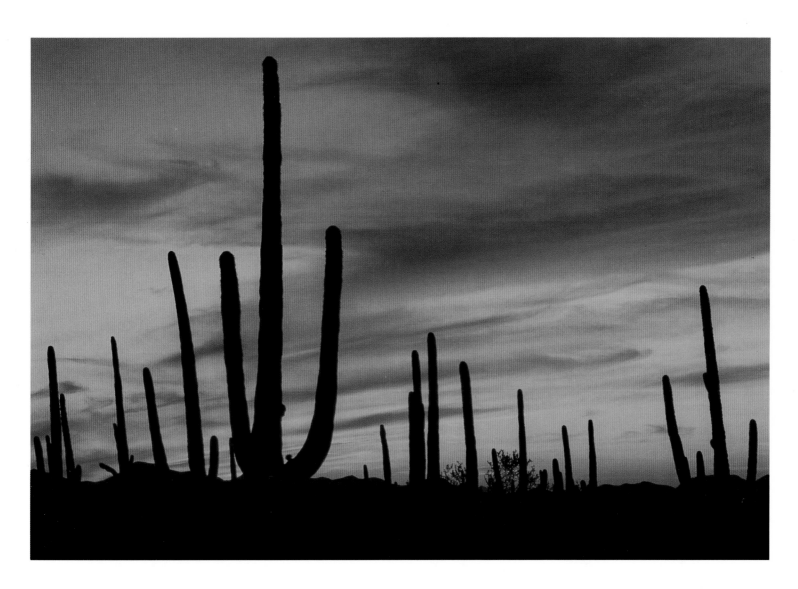

SAGUARO FOREST
SAGUARO NATIONAL MONUMENT, ARIZONA

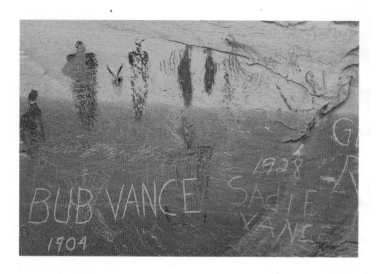

ROCK ART
Barrier Canyon Style and Anglo,
twentieth century
CANYONLANDS NATIONAL PARK, UTAH

Today, ancient sites that endured inviolate for centuries are being torn apart by people of our culture. Pothunting for profit, vandalism for fun, and the pathetic vanity behind them are taking a shocking toll on the legacy of our past.

Tragically, pothunting is often encouraged—unwittingly—by people who appreciate ancient cultures so much they long to possess a bit of them. Shops from Santa Fe to Paris offer prehistoric ceramics for sale at steep prices. Whether or not a shop has obtained a particular item legally matters little; to purchase a prehistoric artifact encourages more pothunting to meet demand.

The clean, dry air of the Southwest has preserved a remarkably intact record of prehistory. Villages made by hand out of dirt and rocks are still standing. Fragile textiles, delicate paintings, and a myriad of easily overlooked clues from pollen grains to feathers have survived to the present day. The fascinating science of archaeology has emerged to put these clues together so that we may honor and learn from the past. However, there are too few archaeologists and scant funding available to prevent the devastation of prehistoric sites taking place today.

In addition to the petty destruction wrought by individuals, public works and commercial projects have drowned ancient sites under reservoirs, gouged through them for roads, and buried them under tons of steel and concrete for speculative developments still empty years after their construction. Perhaps awareness of the cycles of civilizations in the desert can remind us to move more carefully, to consider what is need and what is greed.

And what will our cities look like in a few centuries? Will they say to the future that we respected the land and took care of one another? Will our grandchildren's grandchildren admire us?